Teardrop Traveler

A Visual Tour of America with Mandy Lea & Her Teardrop Trailer

Mandy Lea
Nomadic photographer,
speaker & educator

AMHERST MEDIA, INC. ■ BUFFALO, NY

About the Author

After 17 years of pursuing a conventional photography career, Mandy realized that the American Dream was not for her. She was unhappy in a 9-to-5 job while trying to recover from divorce and depression. She knew there were a few things in life that made her happy: photography and the mountains. Mandy was scared to give up the stability of her normal life, but nothing scared her more than the thought of being miserable for the rest of her life. With an uncertain heart she quit her job, bought a teardrop camper, and headed for the open road. Today, Mandy is a brand ambassador for several products that she uses, believes in, and whose brands share her values. She is regularly published both online and in print, and often interviews on podcasts, television, and at live events.

To learn more about Mandy, visit:
www.mandyleaphoto.com
www.instagram.com/mandyleaphoto/
www.twitter.com/Mandylea
www.facebook.com/themandylea
www.youtube.com/c/MandyLea

Copyright © 2019 by Mandy Lea.

Published by:
Amherst Media, Inc., P.O. Box 538, Buffalo, N.Y. 14213
www.AmherstMedia.com

Publisher: Craig Alesse
Associate Publisher: Katie Kiss
Senior Editor/Production Manager: Michelle Perkins
Editors: Barbara A. Lynch-Johnt, Beth Alesse
Acquisitions Editor: Harvey Goldstein
Editorial Assistance from: Carey A. Miller, Rebecca Rudell, Jen Sexton-Riley
Business Manager: Sarah Loder
Marketing Associate: Tonya Flickinger

ISBN-13: 978-1-68203-376-0
Library of Congress Control Number: 2018939052
Printed in The United States of America.
10 9 8 7 6 5 4 3 2 1

www.facebook.com/AmherstMediaInc
www.youtube.com/AmherstMedia
www.twitter.com/AmherstMedia
www.instagram.com/amherstmediaphotobooks

Contents

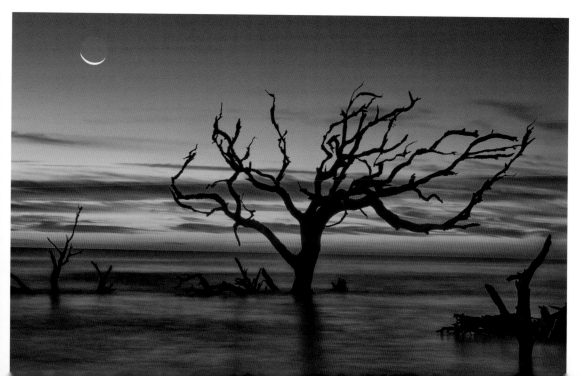

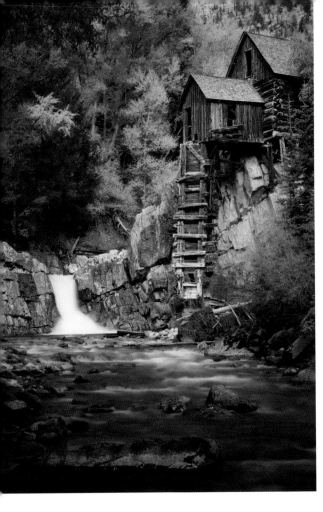

Introduction

Throughout our lives, we change as individuals. With each experience lived, mistake made, and lesson learned, we become a different version of ourselves—for better or worse. Every now and then, we live through a change so drastic that it seems to yield an entirely new life. Such was the way for me as I began my life as a "Teardrop Traveler."

Just as I cannot tell my story without my photographs, I also cannot show my photographs without telling my story. You may simply flip through the pages of this book and enjoy the images I've created of our beautiful country. If you find a few moments of pleasure in viewing an image, I'll consider it a success. And if you care to delve further into the words of my story, I hope you will connect to a small thread of it.

From the day I began this life, my mission has always been to show people things they don't normally get to see, and to inspire them to do things they wouldn't normally do.

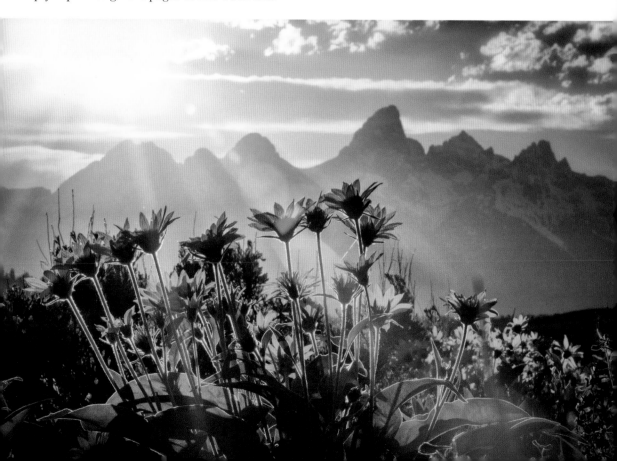

Grand Tetons

The Mountains Made Me Do It

Every story has a beginning and an end, and my story will be no different. While I have not yet reached my ending, I have already lived through many chapters, taking me many places and through many versions of myself.

I cannot define the day I became "a photographer." I have been working in the photography industry since I was 17 years old. Over the years, I grew as a photographer, honing my skills and beginning a career. In addition to a 40-hour-a-week job in a camera store, I began a freelance business photographing events, theater, and portraiture. Needless to say, every hour of my life was filled with work, editing,

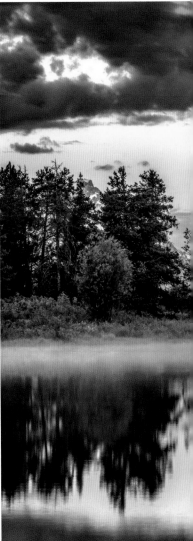

and marketing. I was burnt out and needed a vacation. And thus, I found my beginning in a sunrise—a very special sunrise in Grand Teton National Park *(below)*.

The Art of Landscapes

While I had years of experience under my belt, this trip to the Grand Tetons was my first time dipping my toes into the art of landscapes. It was completely different from anything I knew about photography. I was used to shooting events and theater performances—a fast-paced, fast-thinking environment where you capture the reality of a moment in time.

Landscapes are the exact opposite. I suddenly found myself using a tripod, slowing down and taking time to get to know my surroundings. Finding the perfect spot to set up the perfect composition. And even once I found that perfect spot, I waited for the perfect moment. Rather than shooting a hundred images an hour, I shot five. And I felt peace.

Prior to my first trip to the Grand Tetons, I could count on one hand the number of sunrises I specifically woke up to watch. I am in no way a morning person and would even go so far as to call myself a morning grump. I awoke on the first day of this trip the same way: grumpy. I forced myself into the car in the pitch black of a freezing morning and made my way to my location. Shivering, I set up my tripod and waited. As if scripted in a movie,

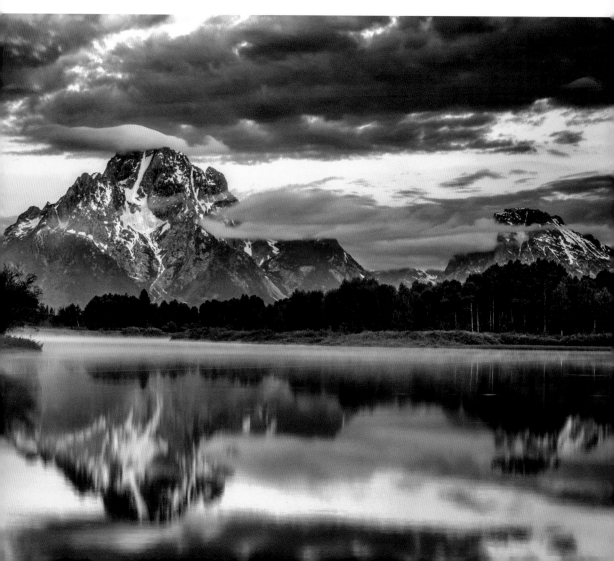

the moment the sun rose, my life changed. As I photographed that single sunrise, I thought to myself, "Mandy, I don't know how your life is going to change, but it is never going to be the same."

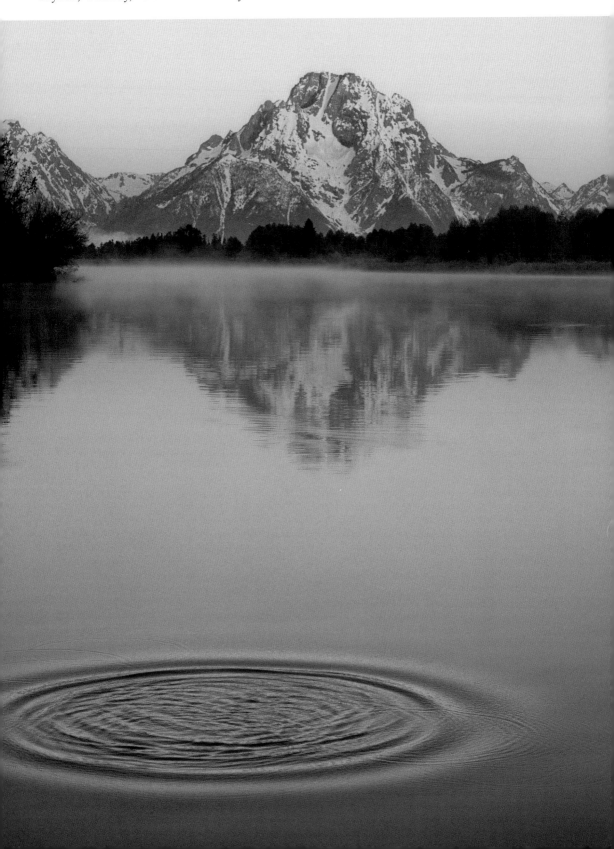

Photographic Ecstasy

I spent that week in photographic ecstasy. I found something that just clicked with me. I smiled a genuine smile and laughed a genuine laugh for the first time in years. When I look at the images I created that week, I realize it was the moment I became the best version of me.

I began by shooting many of the most iconic locations in the park. These areas are crowded, with tripods staking claim to a few feet of space for everything from aspiring to professional photographers. I nudged my way in to see what the buzz was all about. I immediately felt a competitive vibe between all of the photographers. Competing for a shot has never been in my nature. I was far too distracted by the pristine reflections in the water, and the way the sun licked the tips of the mountains to care about someone else's photo. Capturing classic images like these only fueled my desire to see what else these magical mountains held.

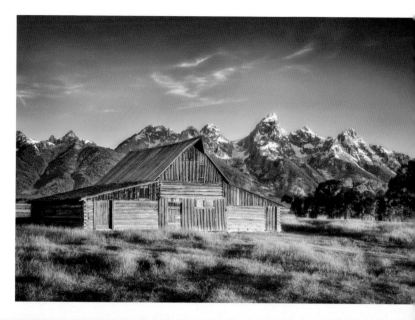

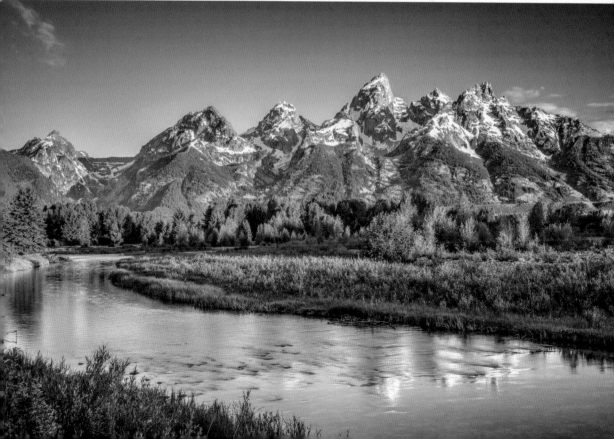

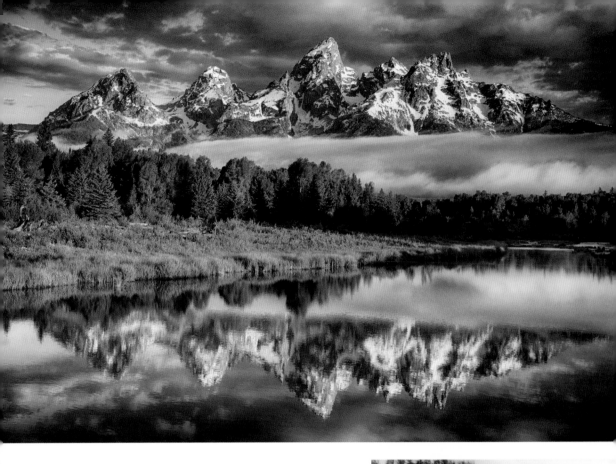

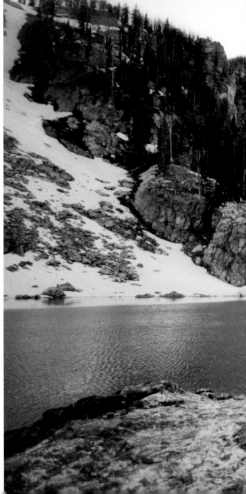

Alpine Lakes

I began exploring on my own, heading up trails to alpine lakes *(right, and next two pages)*. In order to capture the scene at the best time of day, I'd often find myself hiking early before sunrise or late after sunset.

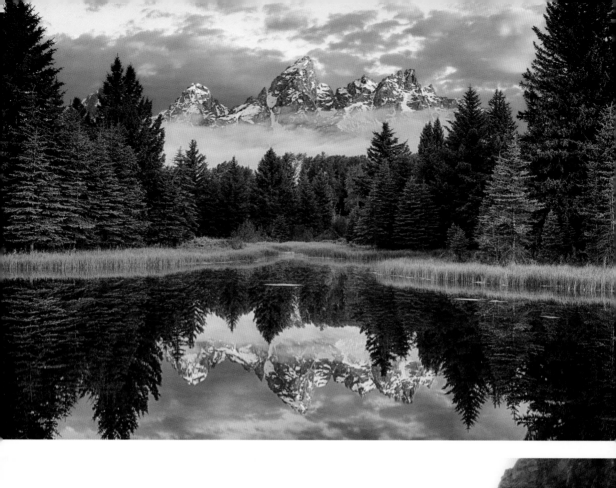
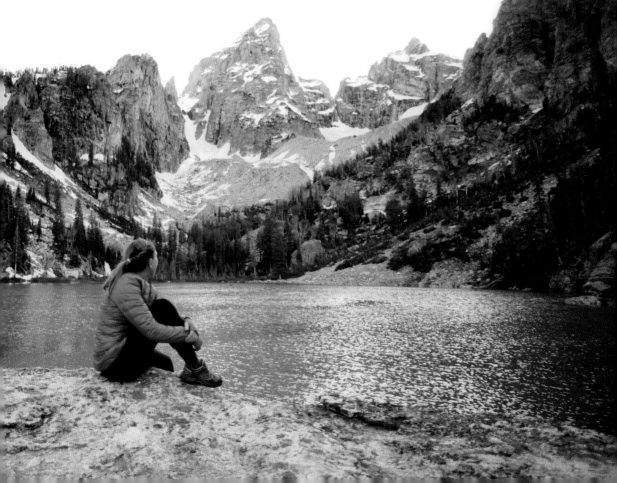

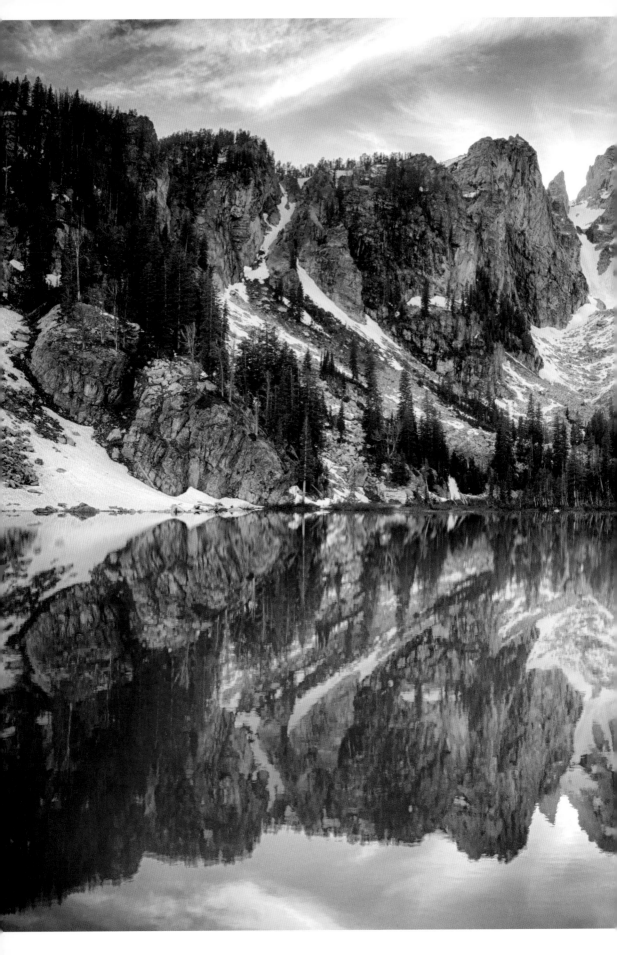

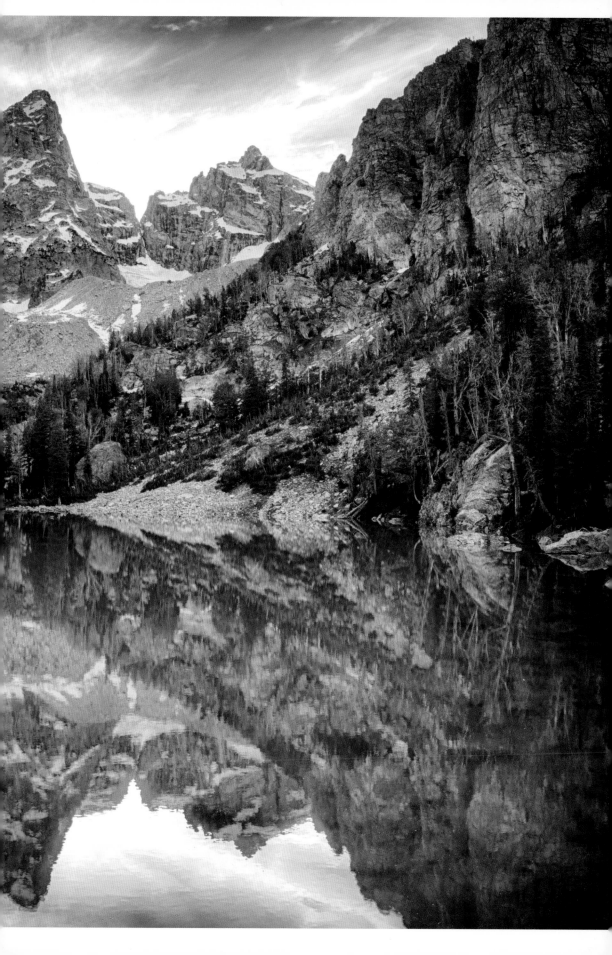

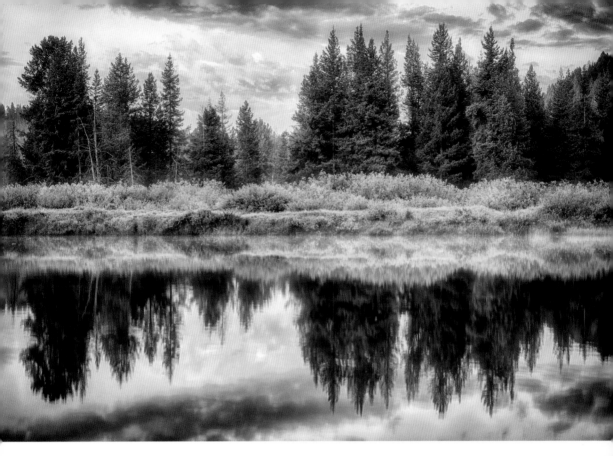

Flowers and Wildlife

I tried to create unique compositions that I hadn't seen online. I included flowers and wildlife when I had the opportunity. I played with different compositional elements and the use of empty space.

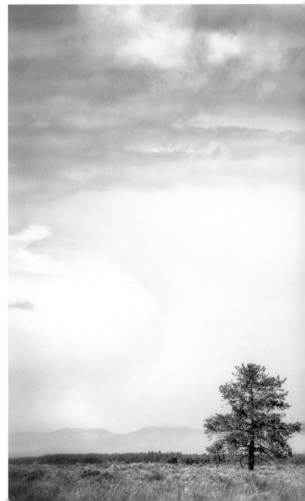

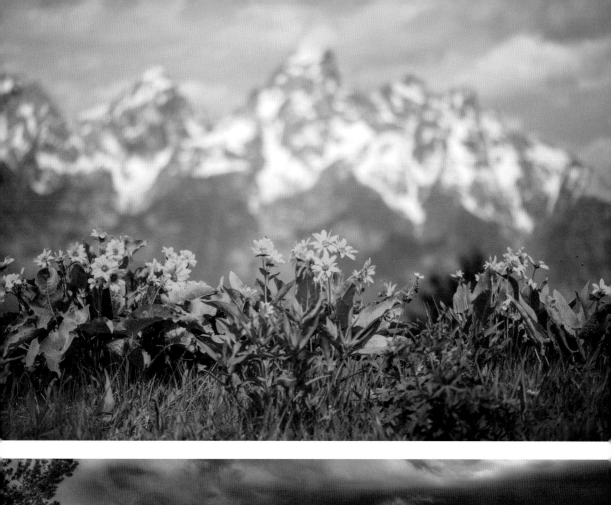

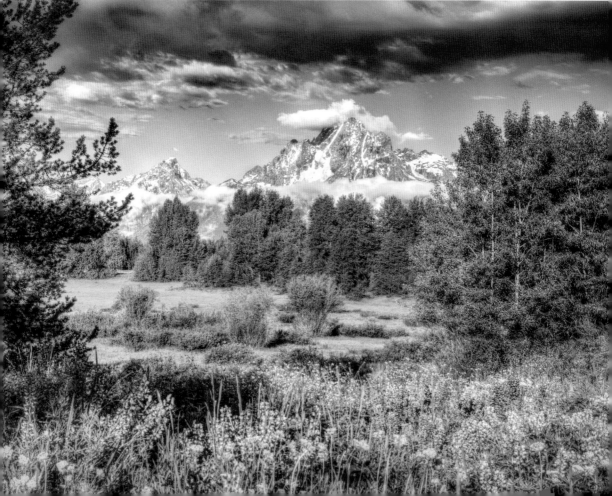

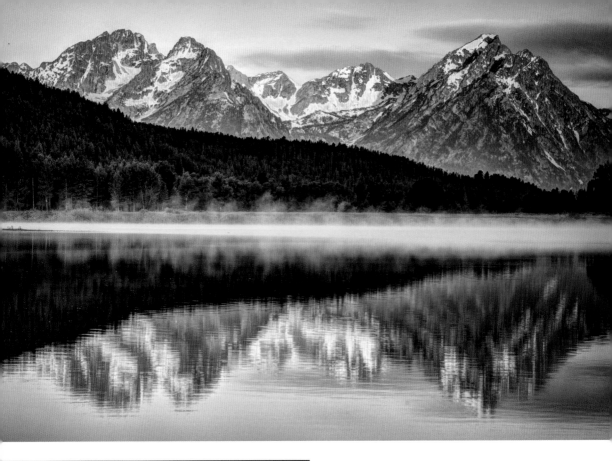

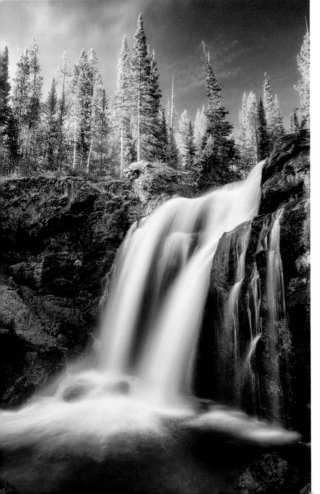

I was enamored by the first buffalo that stood perfectly still while I photographed him and the little birds on his back (*facing page, top*). I felt as if he was posing in front of a fake printed backdrop, but it was real.

In the beginning, I learned a lot from every image. The image of this horse taught me that sometimes we capture what we don't see. As I was editing out dust and imperfections, I almost cleaned up a random blue blur. When I zoomed in I realized it was a speedy little bluebird flying through my frame. I then remembered the melodic chirping I heard when taking this photograph, and so it became a special part of the image; look closely in the space just below the brown horse (*facing page, bottom*).

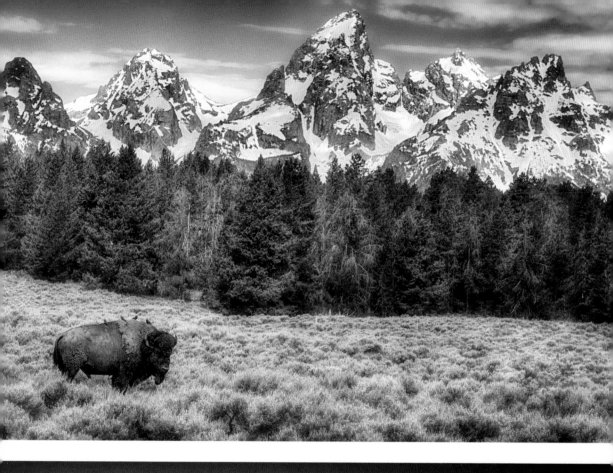
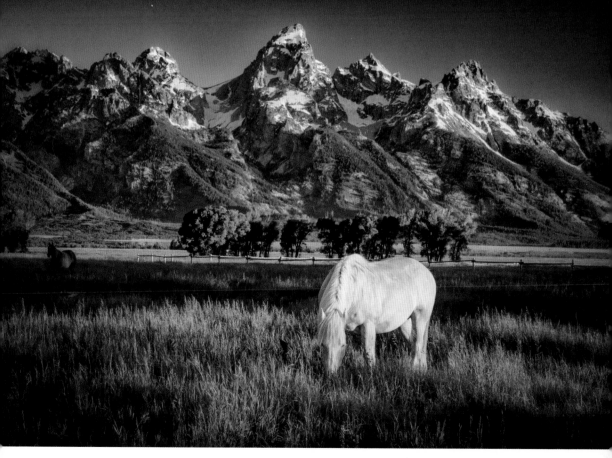

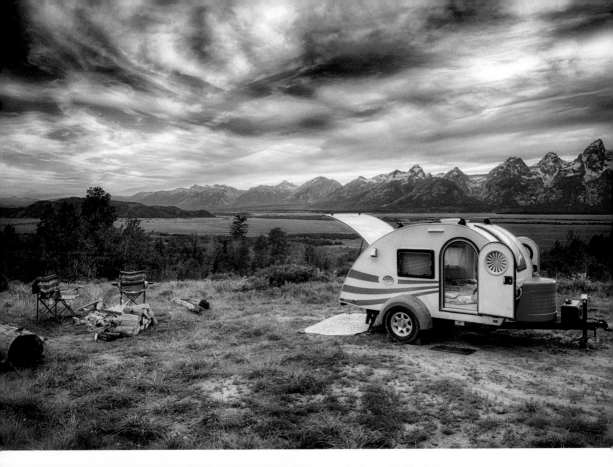

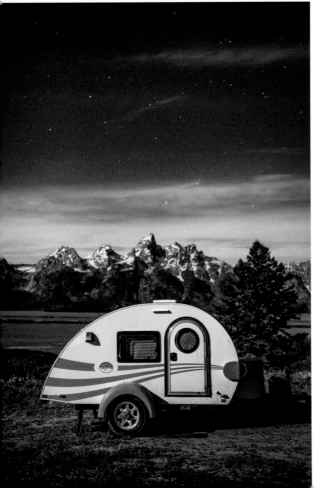

A New World

After this trip I physically returned to "the real world," but my mind was lost far up in the mountains. To be happy, I knew I needed to feed my passion and photograph the natural world around me. The best way I could think to facilitate this desire was to buy a teardrop trailer so I could travel at a moment's notice. Three days later, and without much consideration, I made this idea a reality. I didn't know it at the time, but this purchase would lead to a new world. Eventually, I would return to the Grand Tetons with my teardrop home (*above, left, and facing page*).

And that is the story of how "the mountains made me do it."

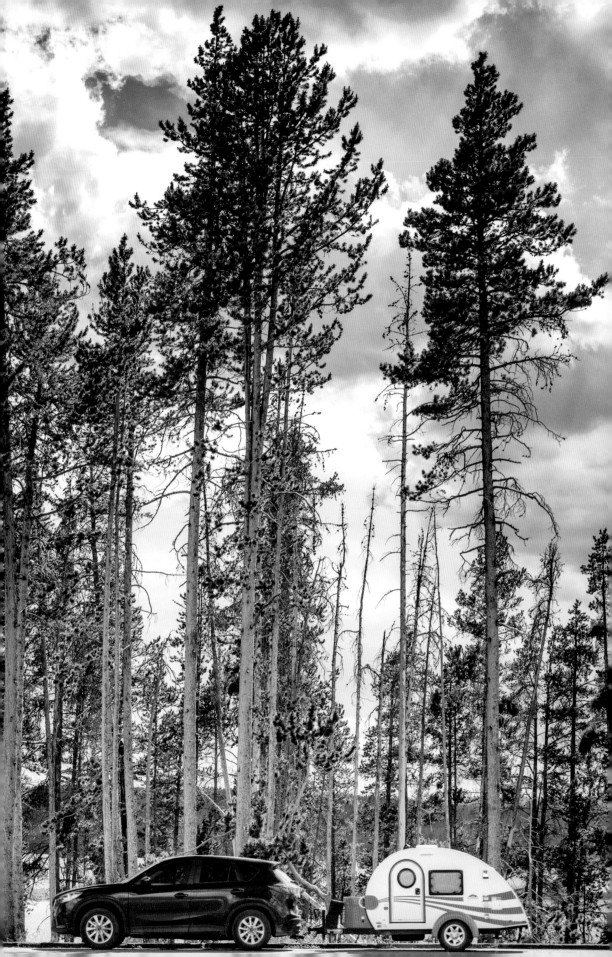

TWO
Texas
The Beginning

My first teardrop was named Bird-song—a cute little white number dressed in vintage aqua stripes *(below)*. When I saw her on the showroom floor I knew she was the one. To this point in my life, I had always bottled up my whims and made the smarter, more conservative choice. I had been married, and along with that came compromise and a level head. Not anymore. I was going to do something that I wanted to do just because my heart felt it. No talking it over or agreeing with anyone—just me. It was liberating.

Beauty Is Everywhere

Finally, it was time to grab my camera, pack the teardrop, and find some nature. As a girl who grew up camping in Colorado, I was dreadfully uninspired by the Texas landscape. But at this point I was still committed to keeping my job and exploring on the weekends, which didn't allow me to venture far from the city. As most things do, this turned into a valuable lesson: If you look hard enough, you can find beauty in unexpected places.

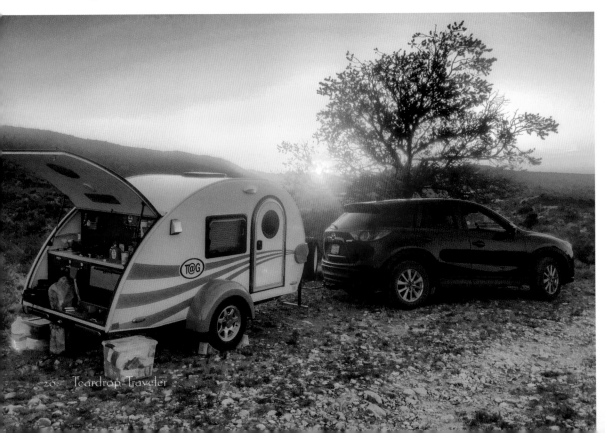

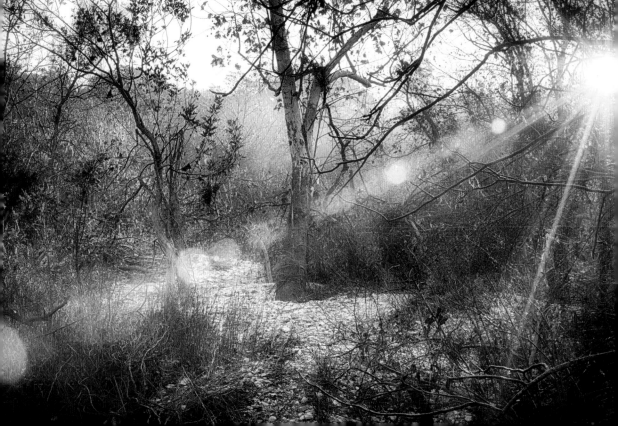

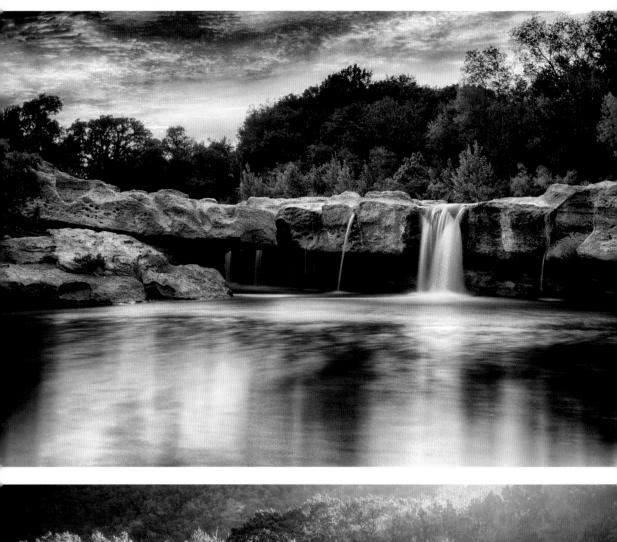
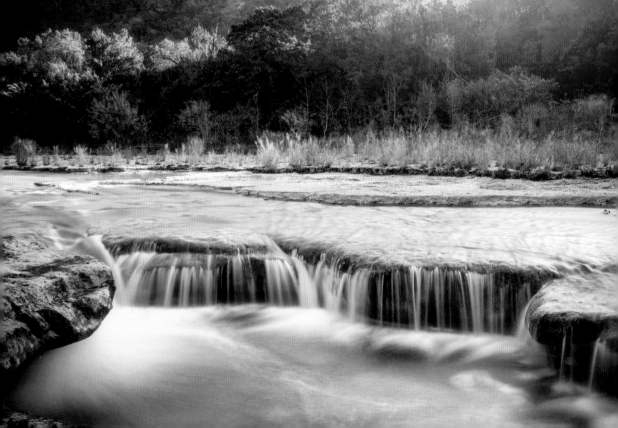

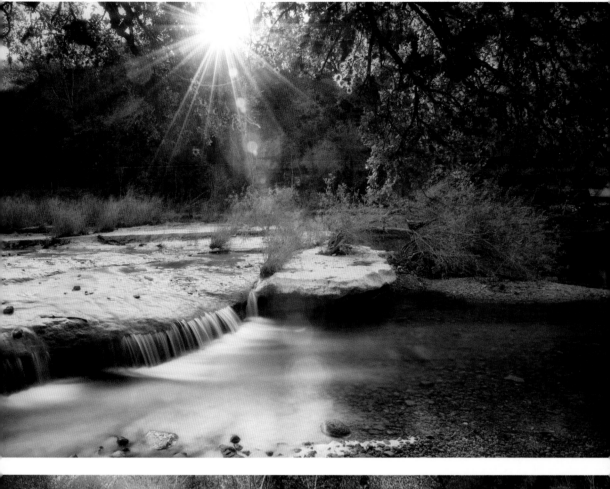

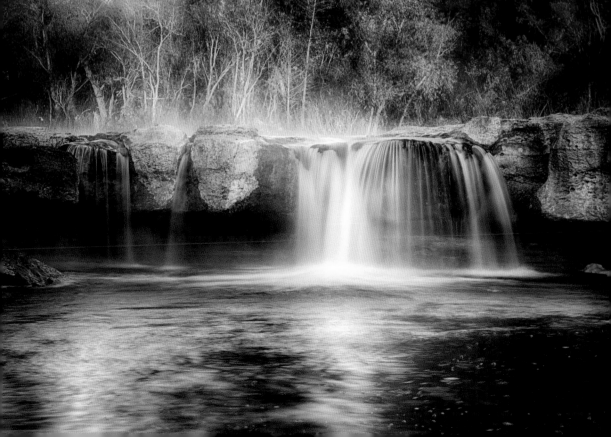

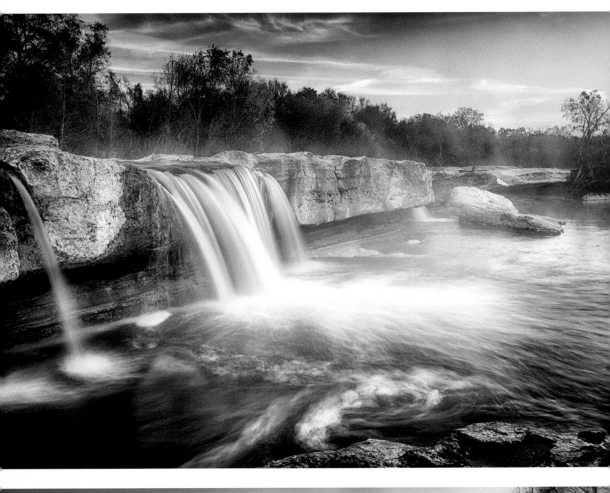
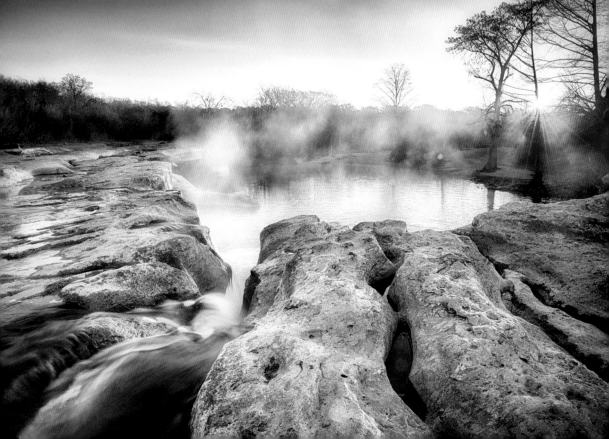

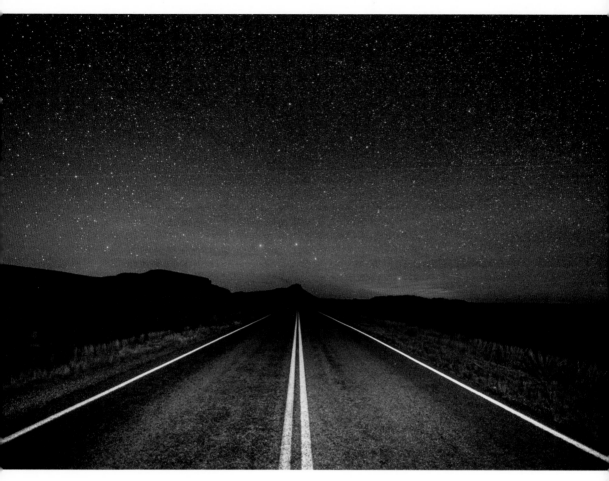

Waterfalls and State Parks

I searched out every small waterfall within a 50-mile radius of Austin (*previous two pages and facing page*) and visited as many of the Texas State Parks as I could. I would often head out after work on Friday and arrive back early Monday morning (unshowered) for work.

Already, my camera and my teardrop were doing two things for me. First, I was visiting places around Austin that I hadn't seen in the ten years I had lived there. Second, I was inadvertently training my eye to see the possibility of a shot that wasn't instantly obvious. Waking up long before sunrise to find a shot became a normal routine. I began characterizing the things that made Texas and the desert beautiful.

Open Spaces

I realized the open spaces of Texas could easily be translated into a dramatic scene (*above*). I remember going out in the middle of the night to shoot the millions of stars in the dark Texas sky. After a few decent but uninspired shots, I asked myself what was really intriguing about this place. It was the vast remoteness, the middle of nowhere-ness, the fact that a person can drive for hours and still be in Texas. And so, I turned to the road and used my headlamp to paint light on my scene and newly meaningful subject.

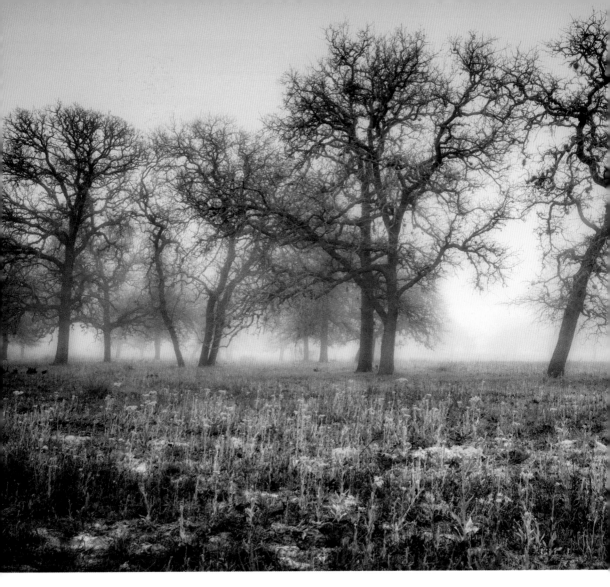

Live Oaks

The plant life of an area helps define its character. I found dramatic live oak trees in the mist of the morning (*above*). I also pulled out a macro lens to capture the essence of the flowers dancing in the Texas sun (*facing page, top*).

Truly Texas

Finally, I challenged myself with man-made objects. The words "Texas" and "truck" go together like peanut butter and jelly, so I had to try to capture this perspective. I found what I consider the epitome of Texas: an old beat-up Dodge sitting in a cattle field (yes, I had to avoid the cows!) surrounded by cactus, all underneath a sunrise in the big Texas sky. I bracketed the image exposure so I could show-case every bit of drama and detail (*facing page, bottom*).

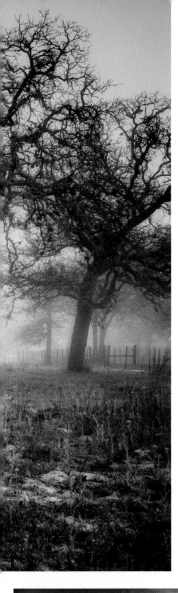

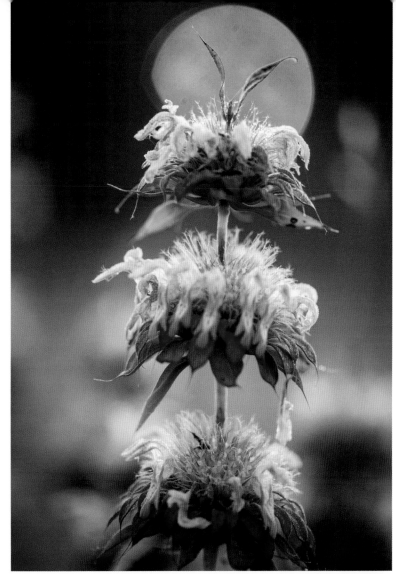

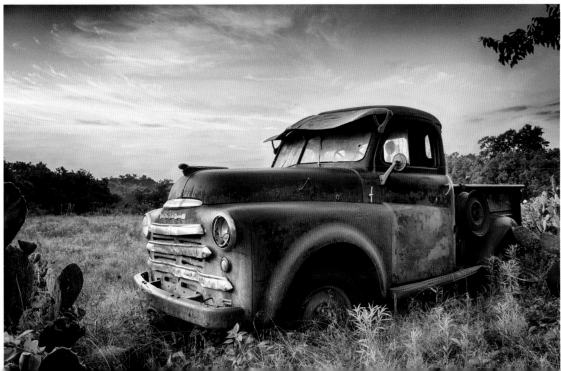

Big Bend National Park

Eventually, I had time to venture further and made it to Texas's only national park, Big Bend. This was the moment I realized that what I had been shooting around Austin was miniscule compared to what was out there. I realized that simple weekend excursions were never going to scratch my itch for adventure.

Big Bend opened my eyes to a new level of landscape photography—dramatic geological features stood out at every turn. The west Texas sky provided intriguing sun, moon, and star scenes. I photographed at all hours. When the moon was full, I would capture it on the horizon *(below)*. In the dark night sky I found the stars reflected in the Rio Grande *(page 30)*.

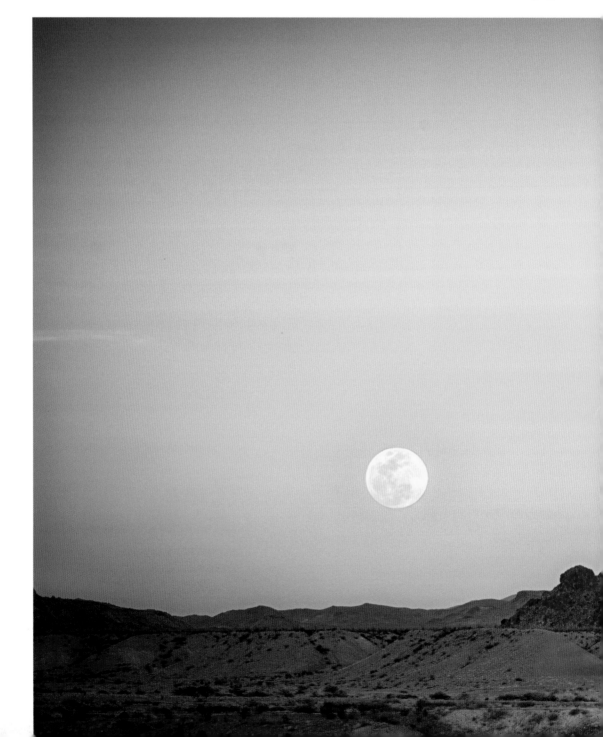

How could I go back to work knowing all this beauty was out here?

Rock Bottom

Now, this is the point in my story that gets the most questions—as well it should. What made you finally do it, Mandy? How did you find the courage? Weren't you scared? Yes. I was scared to death to abandon the conventional life I always thought I'd have. I was scared to lose the comfort and security of a steady job, insurance, and routine life. But one thing scared me more than all of that: the thought of never being happy again. With a painful divorce leaving me in a state where I didn't want to live, putting endless hours into a job that would never grow

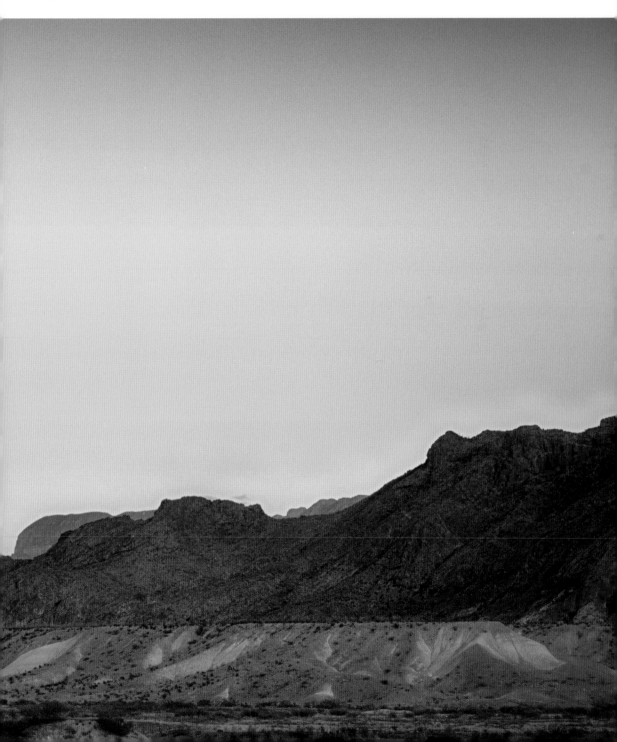

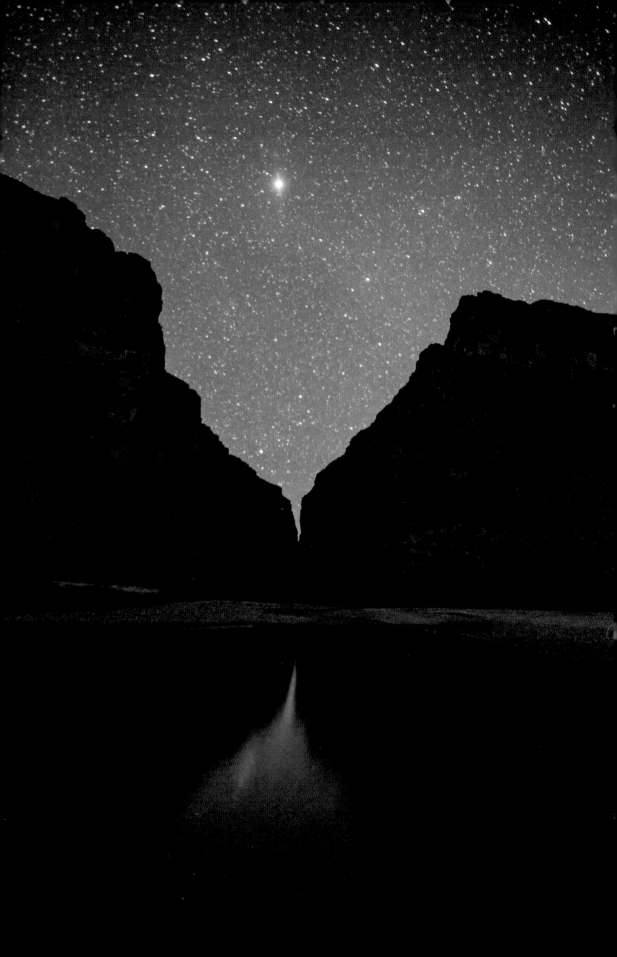

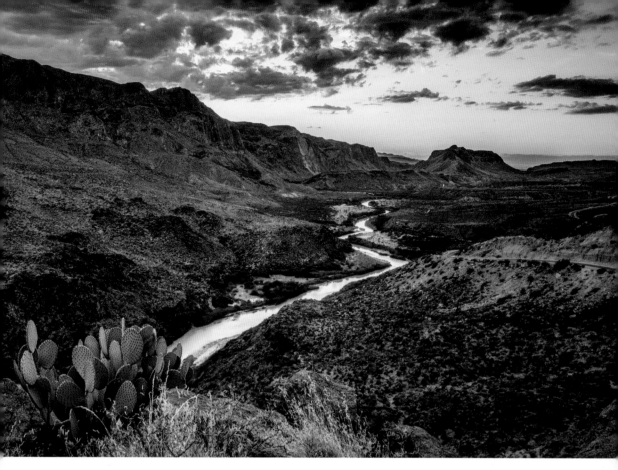

me personally, and anxiety so deep I was in denial, I simply couldn't see the light at the end of the tunnel. I guess you could consider this my "rock bottom."

Why Not?

As painful as it was, hitting rock bottom led me to the question that saved my life, and one I often ask others: "Why not?" And I mean that seriously. Sometimes there are very valid reasons why you can't reach for your pipe dreams. But more often than not, if you actually list out your reasons for "why not," you will find they are excuses rather than reasons. As I sat and looked at my list of excuses, I made the decision: I'm quitting my job, I'm giving away my stuff, I'm living in my teardrop to photograph the world.

Starting Over

It's important to note that this was not an "I'm going on a trip to find myself" decision. This was a complete lifestyle change. I did not have a huge savings to live off of as I leisurely toured the country. I did not plan on being a couch-surfing-starving-artist. I planned on making this my real career.

This meant I was starting over with a new photography business. Everyone asked me what I would do when it failed. As cliché as it sounds, I truly believe that if you want something bad enough and work hard enough for it, there is no other option but to succeed. I had no Plan B, and I was okay with that. For once, I trusted *me*.

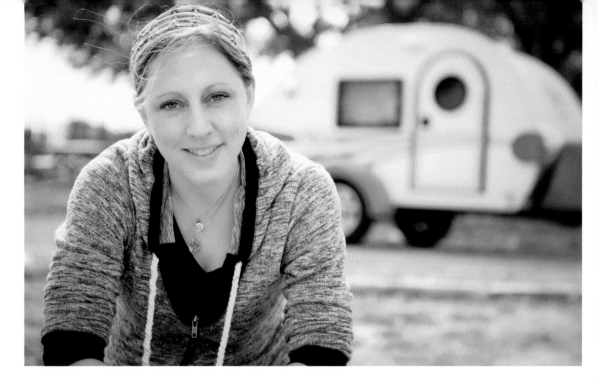

Heartbreak and Persistence

I quit my job, I turned in my apartment notice, and gave away or donated most of my belongings. I began packing my car and teardrop for life on the road. In thirty days, I was out of there. I was ecstatically in love with Birdsong, and even had a tattoo of her on my foot. So you can imagine my shocking heartbreak when I walked outside one evening to nothing more than an empty parking spot where I kept her. I was stunned into silence.

As teardrops were rare at the time, and my friends knew of my obsession with mine, I posted a simple plea to my Facebook friends: if they saw it, please call the authorities. I woke up the next morning to thousands of messages. Perhaps it was the world sympathizing with an unfair crime, or maybe it was just the photo I posted of a young single girl with her teardrop (*above*), but it went viral overnight.

On the verge of being out of my apartment, I was stressed beyond belief. I imagined going back, begging for my job and apartment, or even just postponing for a few months. Instead, I began reading the messages from complete strangers. And this is when I realized the purpose my photography would serve—not just as pretty pictures, not just something to hang on

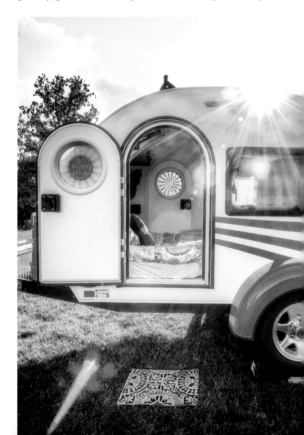

the wall, but as a way to give back to all of these people the same inspiration that they gave me.

And so, I persisted. I went through the insurance process as quickly as possible while tying up the loose ends of my life. I left Austin the very same day that my new home, Phoenix, arrived on the truck *(below and facing page, bottom)*. We had a messy start, Phoenix and I, but she would go on to take me wondrous places. Inside, I hung an image of that first Teton sunrise to remind me of my purpose.

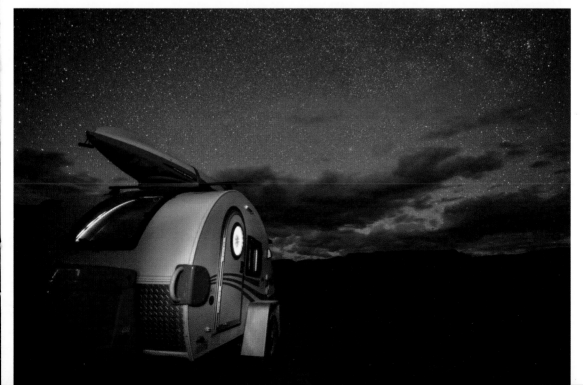

Exploration Begins

A Little Bit of Everything

As I drove out of Austin, I realized that I was inadvertently leaving town exactly ten years to the day after I had moved there. I laughed out loud. Alone. I probably looked crazy, but it was a good sign of things to come. I felt like a child who had just learned to walk. It was time to see what was out there. From the west coast to the east coast, I tried a little bit of everything.

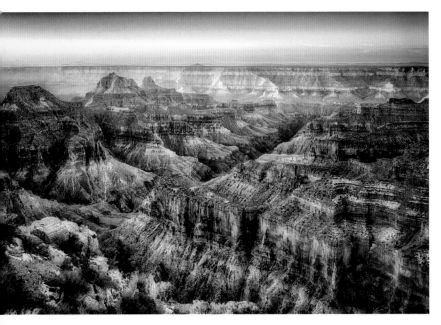

Utah

I have visited Utah several times over the years. From extreme heat to extreme cold, high on mountain tops and low into canyons, Utah offers some of the most unbelievable views you will ever see.

Perhaps the most notable feature of Utah is the Grand Canyon, and it earned its fame for a reason. As a photographer, I almost felt like I was cheating. Taking a beautiful photo was too easy, because everywhere you turned was an amazing view. From the rim, I concentrated on capturing the unique colors of the canyon. I photographed at

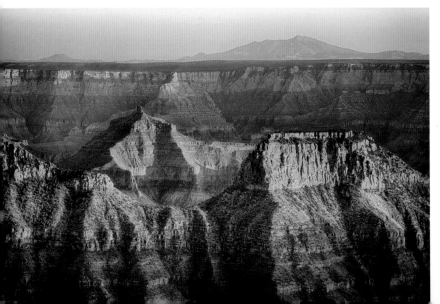

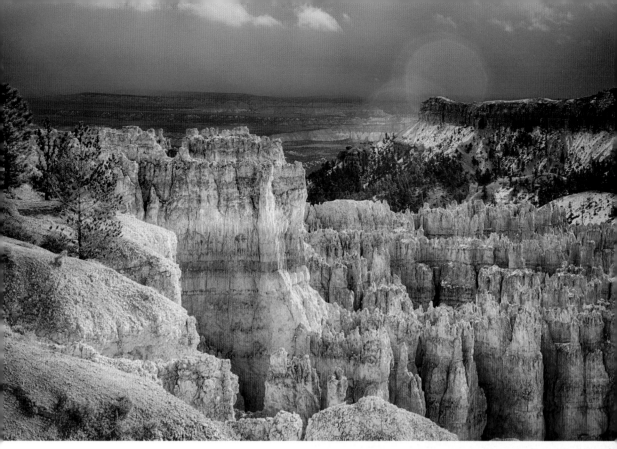

sunset to view some of the colors that were not visible mid-day *(facing page, top and bottom)*.

Canyons are one of my favorite geological features to photograph, and Utah is the king of canyons! Bryce Canyon was one of the first places where I explored the endless possibilities of perspective. I began on the rim, capturing some dark looming clouds over the famous spires *(above)*. It was November and the slight dusting of snow doesn't quite tell the story of just how freezing it was.

I then hiked down the trail to the bottom of the canyon. While the views in front of me were gorgeous, it wasn't until I looked straight up that I found my shot. The sky had cleared to a bright blue, and the combination of red, green, and blue captivated me *(right)*. I thought to myself, "Nature sure does have good taste!"

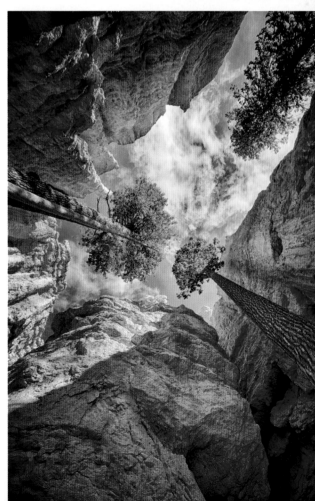

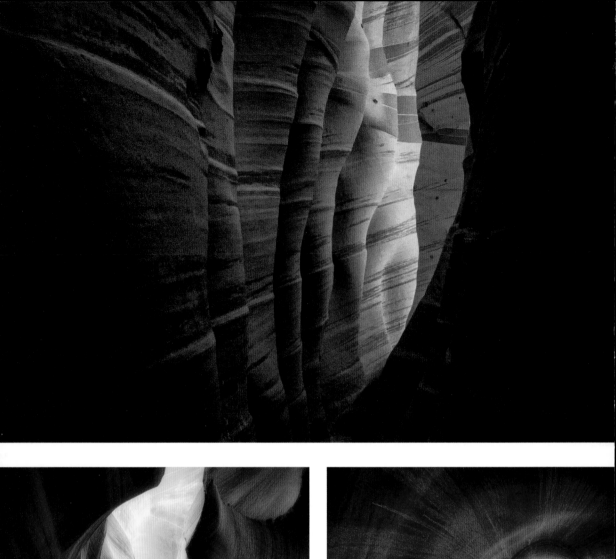

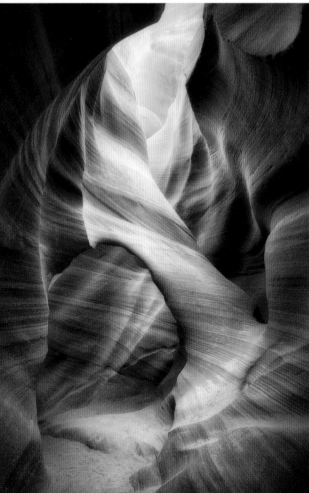

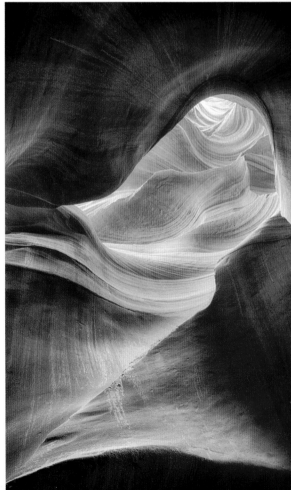

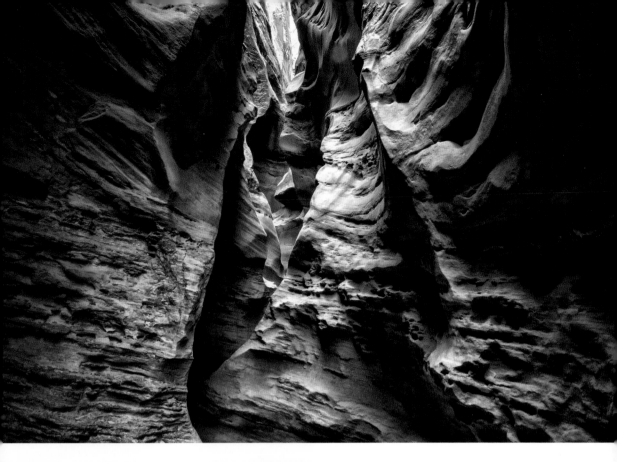

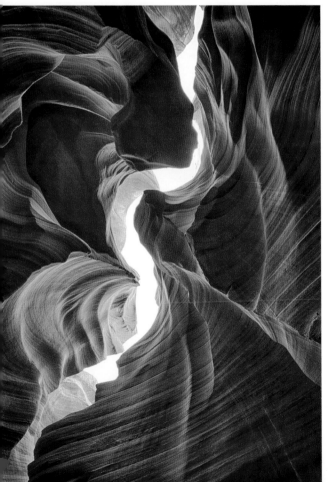

I found that the light bounces around canyon walls like nowhere else. The shadows emphasize the texture of the walls, while the light leads you to mysterious places.

I could walk through the same canyon a hundred times and never take the same shot. Around every bend is a new curve of rock or pattern of light. In these canyons, I learned that sometimes moving just inches one way or another could completely change your composition. This was a lesson that would stick with me through the years.

The canyons weren't done teaching me lessons though. I photographed a very popular location, the Narrows in Zion Canyon. Full of photographers and hikers constantly in and out of my frame, I learned the very frustrating virtue of patience. I would often have to wait for others to leave, or creatively place myself at an angle that blocked them. This certainly diminished the wonder of the experience, but not the beauty of the canyon *(below, top image)*.

Finally, I learned I could walk in water! I know this seems silly, but I had always been a

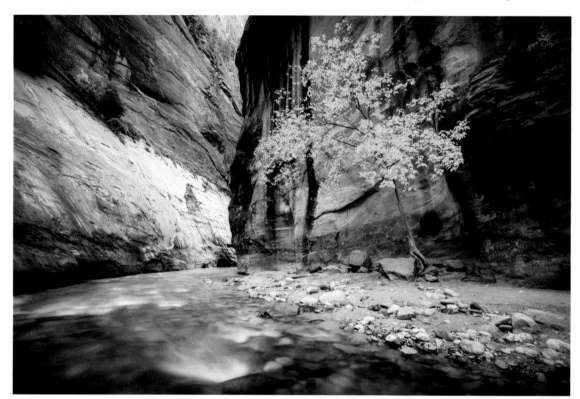

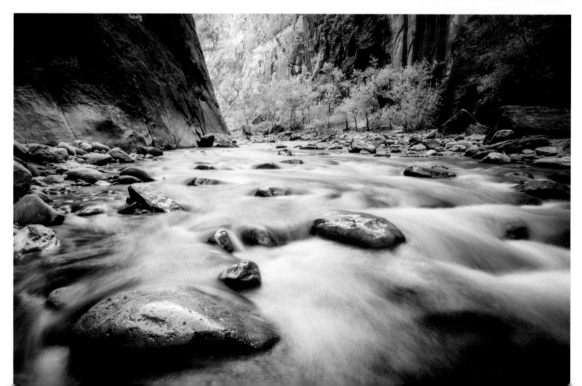

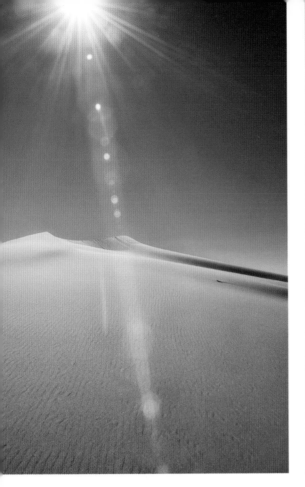

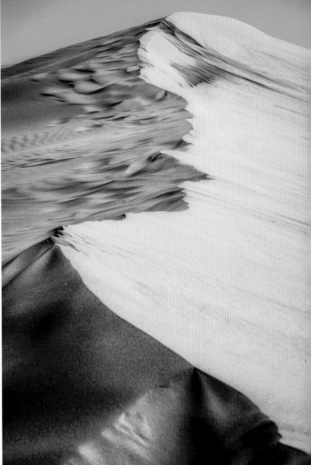

"side of the river" photographer. Realizing that you can stand in the middle of a river (even with your shoes on) and you'll simply get wet, changed everything about photographing water for me. I would go on to stand in every river I could *(facing page, bottom)*.

Inner Strength

The Coral Pink Sand Dunes of Utah *(above)* will always stand out as a place of enormous personal growth. I visited in the off-season and was the only person for miles; not even the ranger station was manned. There was a dusting of snow in the freezing weather. It was the coldest I had yet camped, and I was proud of myself. Nature called in the middle of the night and, with no bathroom in a teardrop, I stepped outside without a coat—since I

would only be a moment. To this day, I do not know how I managed to lock myself out of my camper that night. At first, I was calm, thinking I'd find a way back in. As my options dwindled, I became scared. I sobbed that night and into the sunrise, until finally some kind strangers passed through to take me to town. It took nearly twelve hours of hustling around a small town in Utah in nothing but my pajamas to finally find a locksmith.

In that moment, I grew more than any other day in my journey. I learned that I was a lot stronger and more capable than I thought. When I look at my images from Coral Pink, this is where my mind goes. The beautiful sweeping lines in the sand and sun bursting bright in the sky take me back to that day and remind me of my strength.

I later visited Utah many more times. When I returned in the winter, I reflected on my growth since that event in the sand dunes. I photographed the deep, still snow among the pine trees and the frozen waterfalls. The smile and the joy I see in these images is because I grew into the person I knew I could be, and it is equally reflected in my photographs.

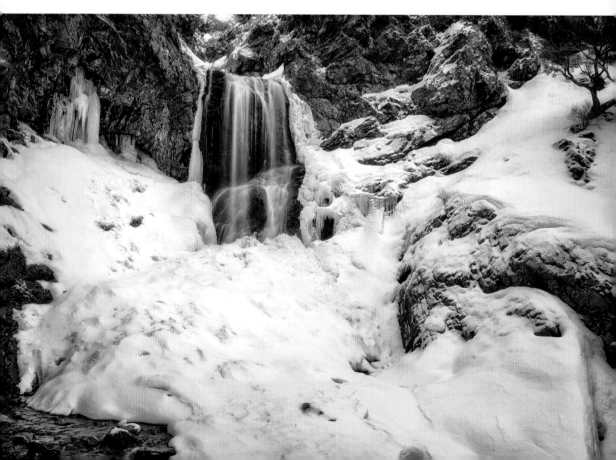

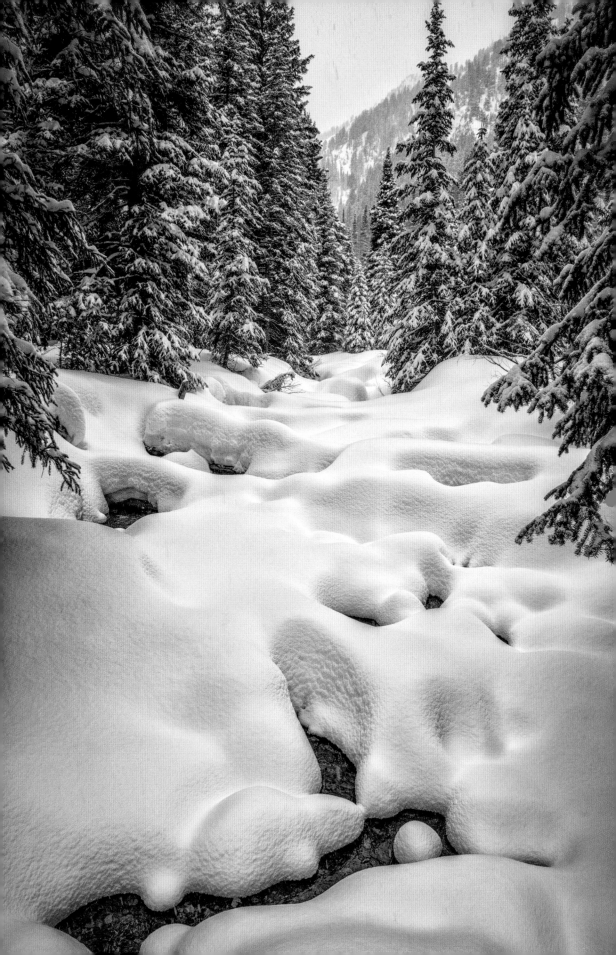

The Southwest

The Southwest is where I found a lot of my early inspiration. I was already in love with the mountains of Colorado and the desert of Texas, and the Southwest proved to be a mixture of the best of both worlds. I learned that Nevada is much more than just Las Vegas. It is also home to beautiful red mountains in Red Rock Canyon *(below)*. I photographed them at sunrise and spent the day hiking their trails.

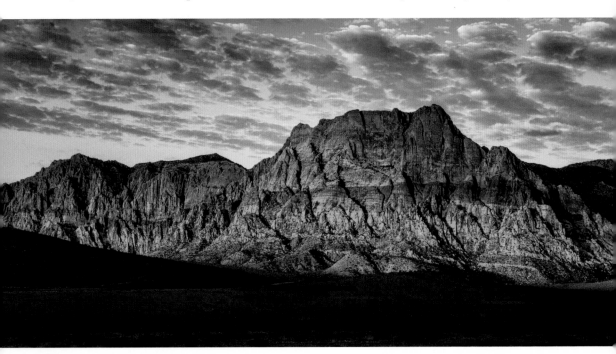

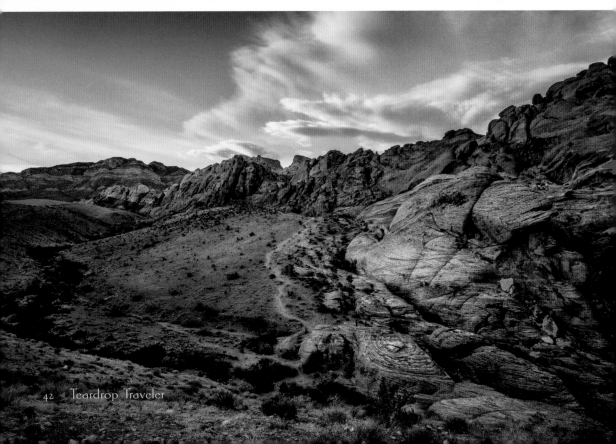

It was in Arizona that I had my first experience backpacking as a photographer, which was much different than backpacking as a non-photographer! Trying to find the right balance between not taking too much gear while also having everything I wanted for my images was a challenge. I finally accepted the fact that I was going to have a ridiculously heavy pack, and I was okay with that because photography was the purpose of the trip.

It was 20 miles round trip to Havasupai Falls *(right)*. As I was hiking among others with nothing more than a day pack, I realized that almost everyone paid to have their gear either packed by mule or helicoptered in. "What lazy cheaters," I thought. With a slight air of pride, I made it to the most brilliant falls I have seen to date.

People have asked me why I added so much saturation to my images—and I tell them I must not have *removed* enough! The water was out of a fairy tale, blue and brilliant.

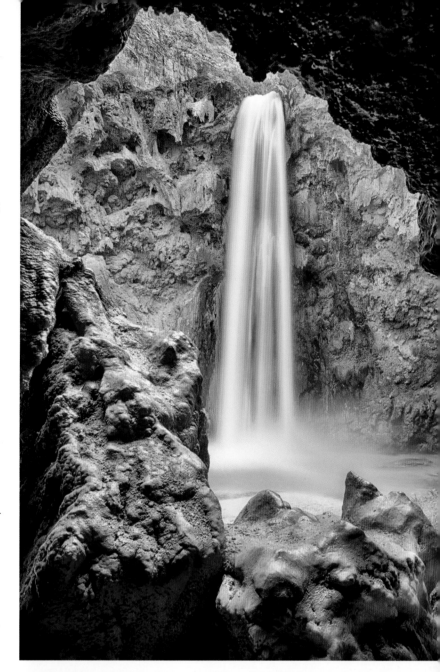

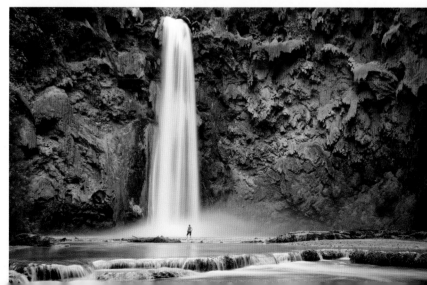

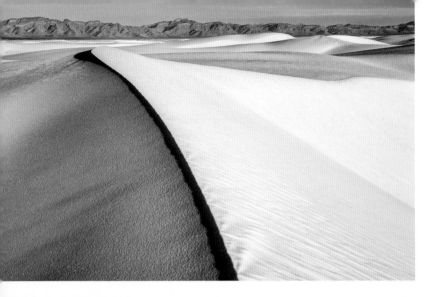

Eventually I found my way to White Sands National Monument in New Mexico. I found something peaceful about the endless rolling hills of clean white sand, blowing gently in the breeze. I spent time running barefoot, doing somersaults, and sifting sand through my fingers until the sun set. I am convinced that there is never a bad sunset in White Sands, regardless of the weather. It is silent and peaceful listening to the gentle breeze. The landscape here allowed me to play with negative space in my images: intentionally breaking the rule of thirds and making use of the vast white and blue emptiness, with the occasional lonely desert plant.

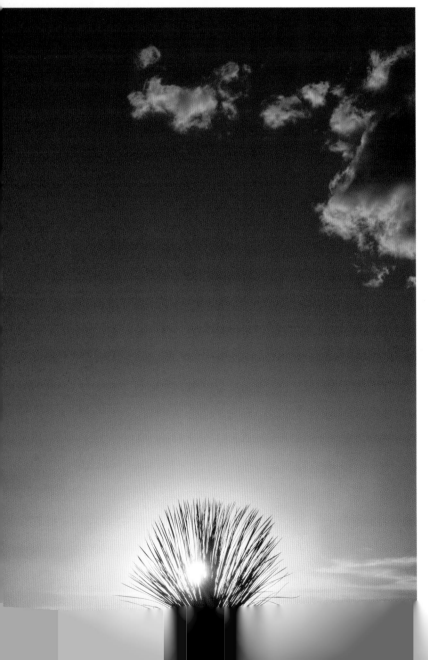

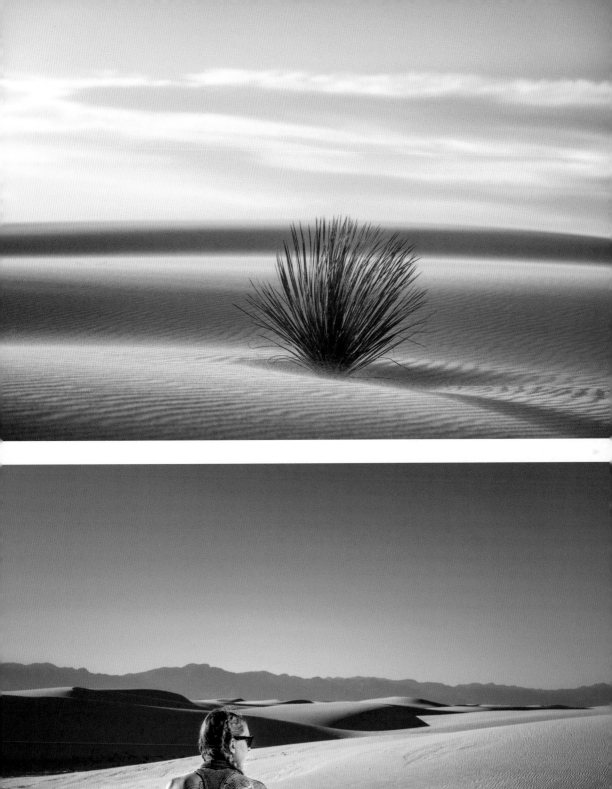
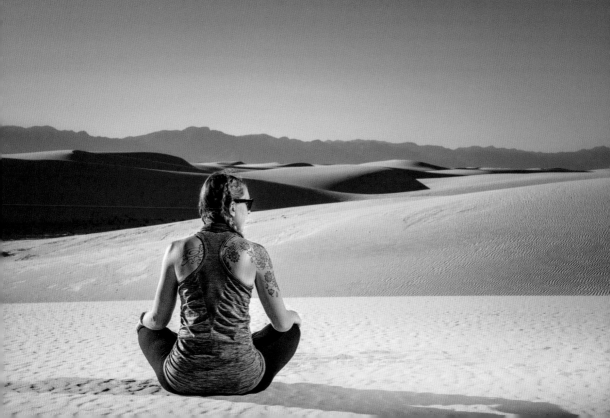

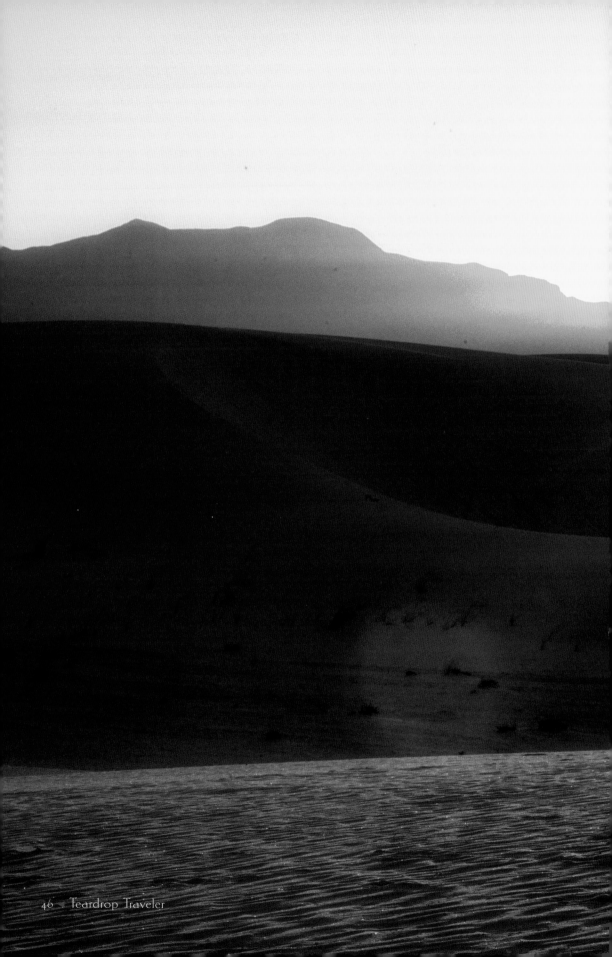

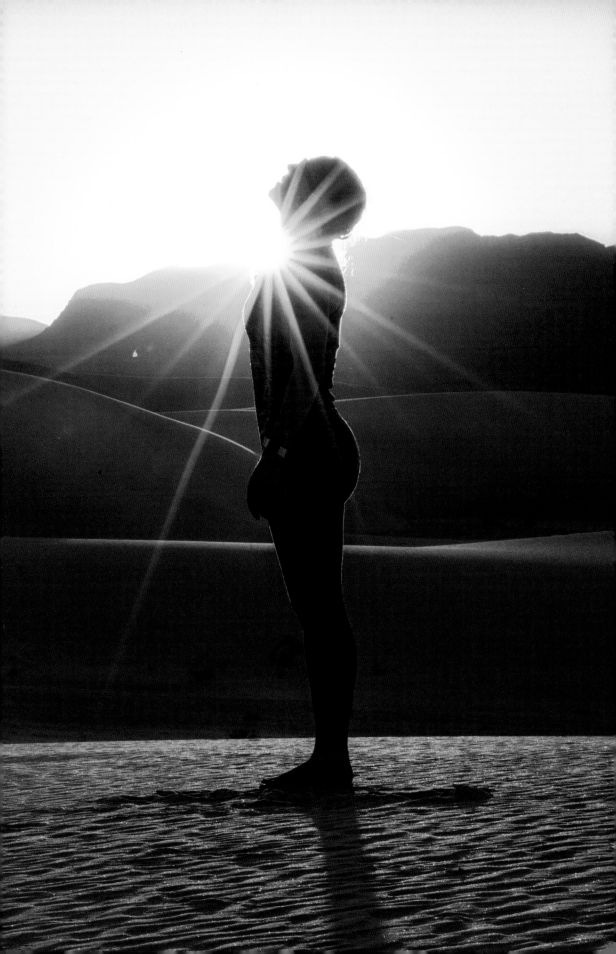

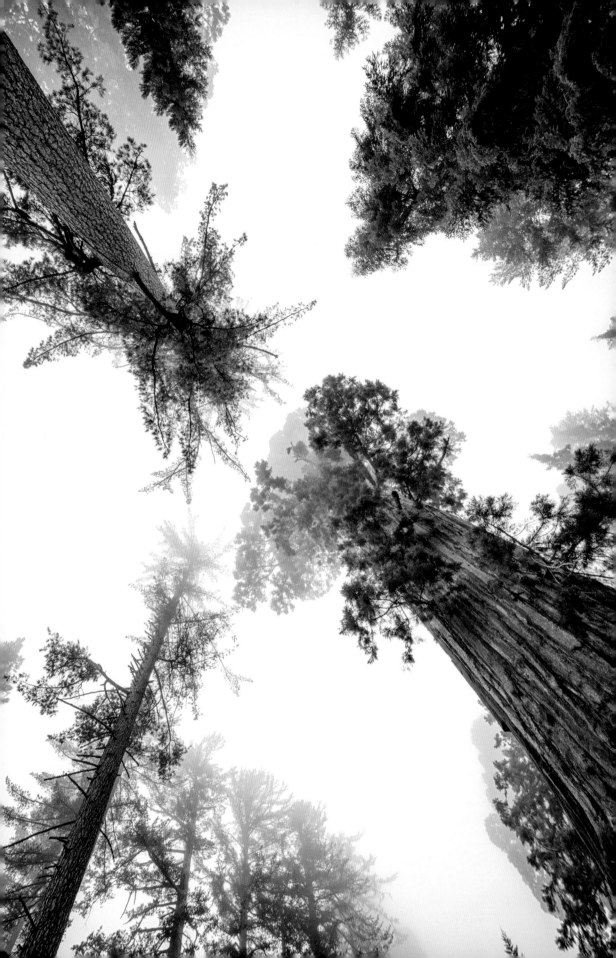

West Coast

I had gotten to know the mountains and canyons. Now, it was time to spend some time with the trees. But not just any trees, the trees of Sequoia National Park. I had seen photos of these giants, with people like ants spreading their arms around the trunks. But to stand among them and feel the age of the ancient forest is something indescribable. Looking up was simply humbling (*facing page*).

To capture the serene essence of these trees, I needed to escape the crowds and cars. If there is one thing I've learned that all National Parks have in common, it's this: if you hike a mile away from any parking lot, you instantly lose the crowd! I chose a nice 5-mile hike to a lake on the off chance I could capture some nice reflections as well. The effort was well worth it (*below*).

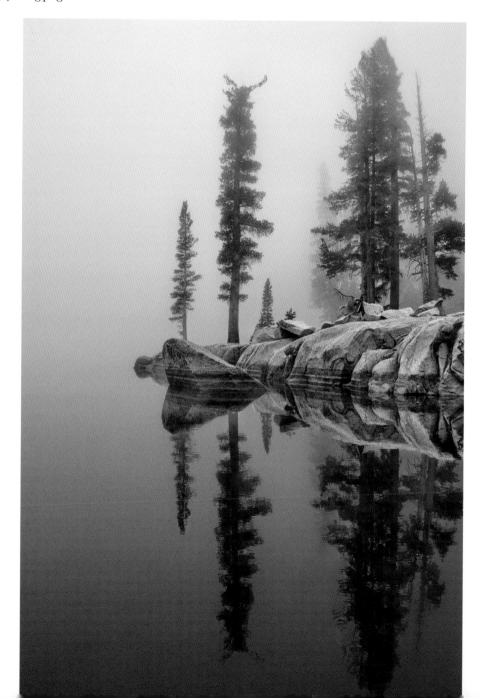

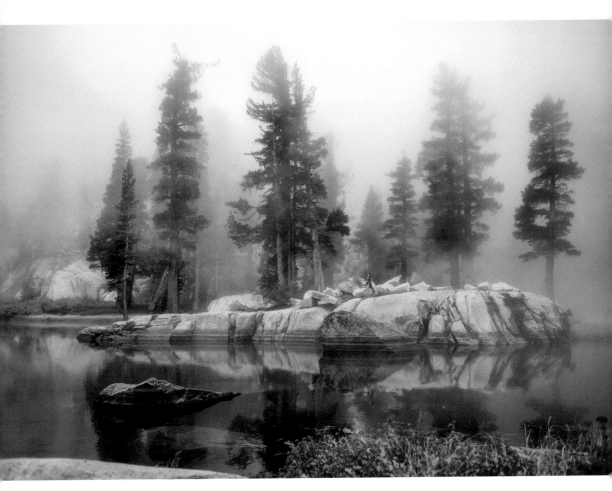

It was such a cloudy day that sometimes I couldn't even see the other side of the lake. Then, in the course of minutes, the clouds would blow through and I would momentarily get a glimpse of the wonderland in front of me before it disappeared into the clouds again (*above*). I must have sat in the same spot for over an hour—shooting when the moment was right, and just breathing in when it wasn't. In this, I learned that the simple act of taking time to experience our art improves it.

I know the west coast has endless photographic opportunities, and one could spend years there without seeing it all. It's a big country and I expect to revisit California, so for now I gave myself the penny tour up the coast. While planned shoots at specific loca-

tions yield the best results, do not discount the random views you may encounter along the road! I may see a sign for a waterfall or simply be awed by a sunset as I drive by (*facing page*). These aren't usually my winning shots, but they keep me on my toes and make me smile.

I learned that the simple act of taking time to experience our art improves it.

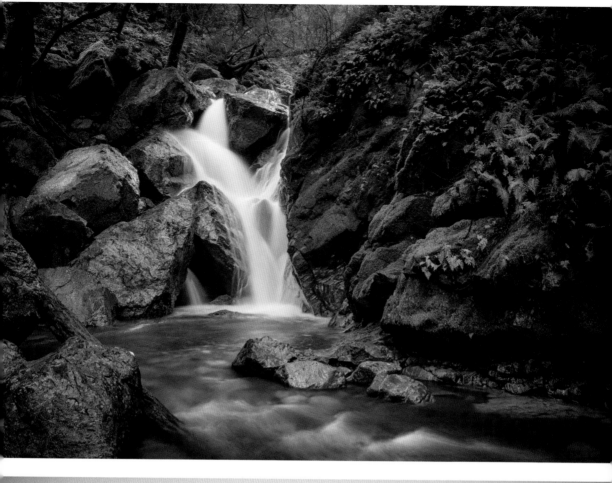

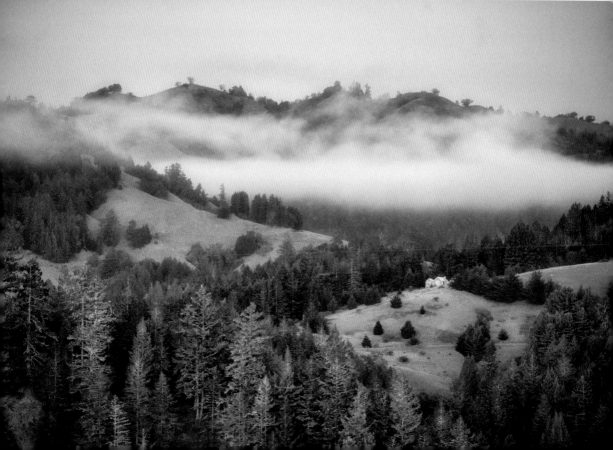

I couldn't visit California without exploring the iconic ocean piers and, of course, photographing the Golden Gate Bridge *(below)*. I don't typically enjoy shooting man-made objects because I simply can't connect to them. But on occasion there will be a structure that lends itself to the landscape. It may be an abandoned piece of history or a magnificent human accomplishment, but all of it is part of the story of our planet.

Oregon *(facing page)* left me with a small gift as a reminder to come back to visit: a faint rainbow in a wonderfully moody sky. Sometimes the landscape talks to you. If this image could speak it would say, "It's okay, Mandy. I know you are busy. Come back anytime."

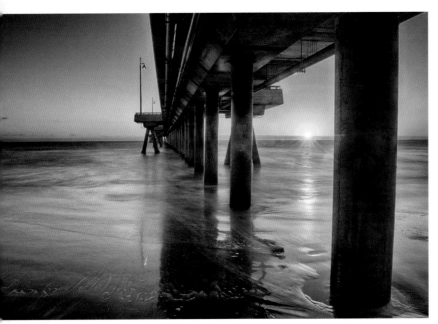

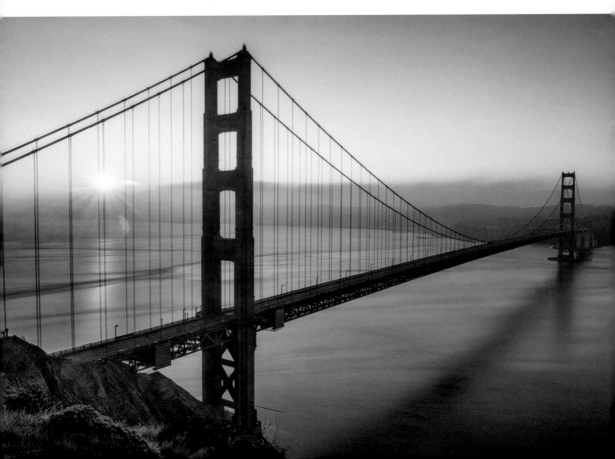

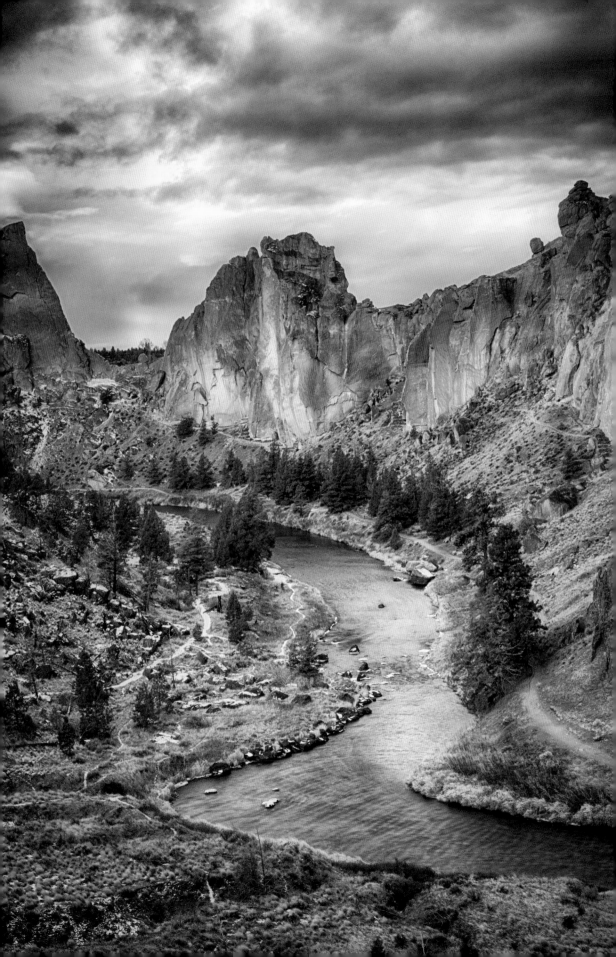

Across the North

There are many different types of full-time travelers. The majority are seasonal, staying in a single location for weeks or months before moving on. And then there are those like me—deemed crazy for traveling often, traveling quickly, and not always following a geographically logical route. The benefit to this nomadic lifestyle is that when opportunities arise, you have the freedom to say yes. As a result, I traveled to many places I wouldn't normally have visited.

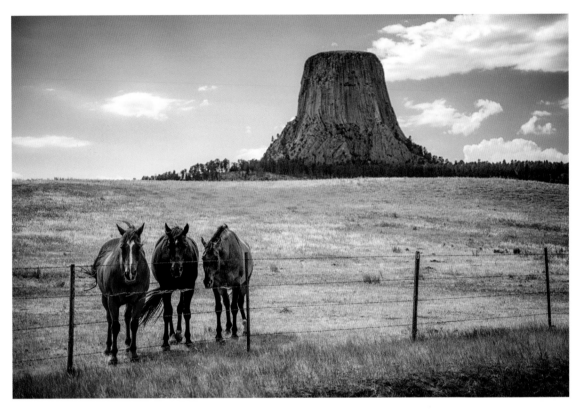

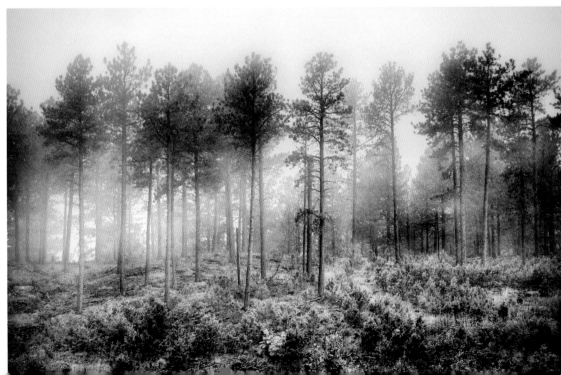

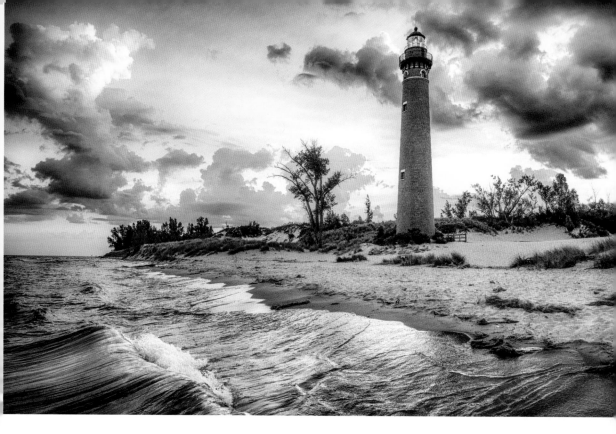

In South Dakota, I visited Devil's Tower. I set expectations for myself to photograph it in a particular way: a grand, towering rock shot from the base. I hiked the circumference of the tower and was moderately pleased with my results. But as I drove away, three horses caught my eye. The tower was far in the distance and standing out prominently against the sky (*facing page, top*). In the end, this was the shot I connected to—the one that moved me.

With this sudden inspiration I simply drove the back roads of South Dakota. It was a gloomy day, but the kind that adds wonderful mystery to the surrounding forest (*facing page, bottom*). I realized that setting expectations in landscape photography usually does nothing more than set you up for failure.

I jumped at the opportunity to park in a Michigan driveway near Silver Lake—because not only had I never *photographed* a lighthouse, I had never *seen* a lighthouse! The obvious thing to do was visit it at sunset. It was one of the most spectacular sunsets I've ever seen, but I had to share it with a thousand other people. As a tourist destination, the beach was unbelievably crowded. So I decided I would photograph sunrise the next morning and arrived early to catch the first light (*above*). Remarkably, I was the only soul in sight. It was a stark difference to the night before and I thought, "What a bunch of suckers—they missed the most beautiful part of the day!" But I was grateful to guiltily have it all to myself. Photographing the same location at different times of day can be enlightening as a photographer. You learn to capture the light from different perspectives to create unique images.

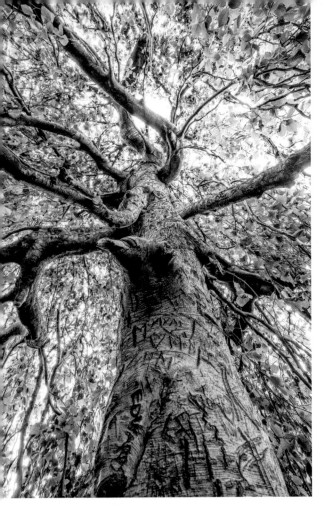

Wanting to take my little teardrop out of the country, I made the international journey to Niagara Falls! Niagara is certainly one of the most breathtaking falls in the world. It is completely developed on every side with man-made structures—a waterfall amidst a city. It made me wonder what it must have been like for the first discoverers. How astonishing it must have been, surrounded by trees and forest rather than buildings. I found myself looking up at one tree *(left)*, scarred over by tourists who wanted to make their permanent mark. It is likely older than any one of them could imagine. In my photograph, I wanted to emphasize the mark that humans have made on this place. I shot it with the intent of making it black & white. It seemed like color was this tree's spirit, and it had been lost.

I finally made my way to the falls. Once I elbowed my way in and used my tripod to stake claim to some personal space, I faced my next

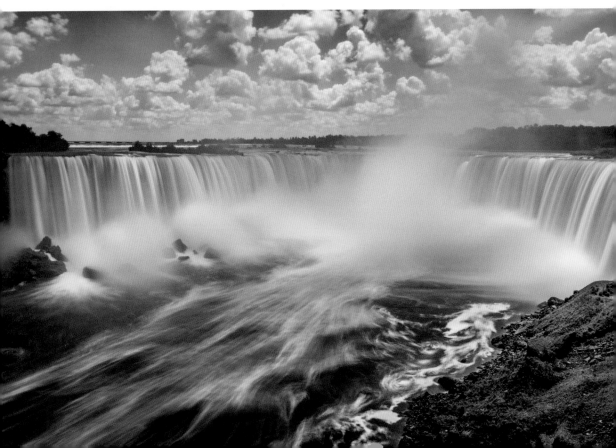

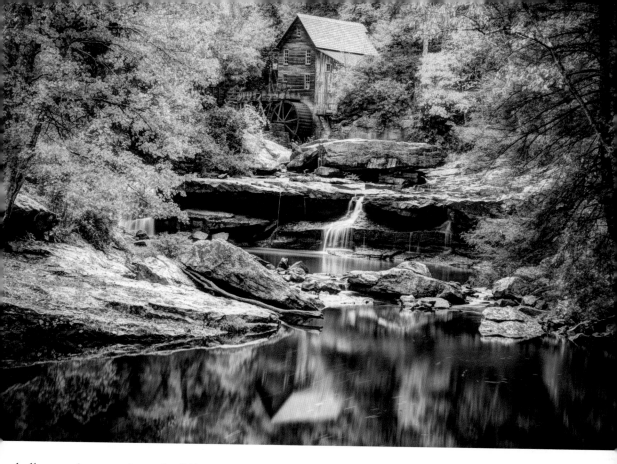

challenge: photographing the falls in the most natural way possible. I wanted a long exposure to add smoothness and movement to the water. The puffy white clouds made for a great sky but would come and go in front of the sun every thirty seconds. Worst of all, there were endless tugboats taking tourists to the base of the falls. This meant I had to find the perfect 20 seconds: solid cloud cover, no tugboats coming or going, and no one bumping my tripod. It took nearly an hour of waiting, but it happened. It seems the lesson of patience is one my camera will teach me many times over.

West Virginia

Although I grew up in Colorado, a state famous for its beautiful Aspen leaves, West Virginia brought me my first experience photographing the colors of autumn. The first time I saw this popular gristmill *(above)*, the fall colors were reflecting brilliantly in the water around it. I was learning to make reflections part of my composition. My shot of the gristmill reminded me of a painting. I began to liken my work to paintings. I've never been a great painter, despite how I tried, but I thought photography could be a great conduit to creating the images I wished I could paint.

It seems the lesson of patience is one my camera will teach me many times over.

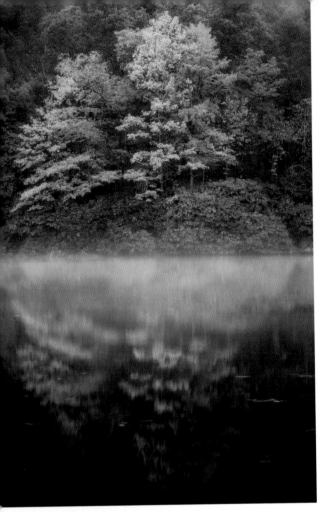

Combining my already growing love of photographing water, with the golden colors of fall was exciting. I played with different compositional elements such as isolating small but interesting scenes *(left)*, or using the foliage to compliment the background of an already beautiful scene *(below)*.

My love for waterfalls was growing exponentially. Anywhere I was, I would look up the local waterfalls on a map and visit them. I was enamored with the idea that I could capture 30 seconds worth of water flowing, and the result would be a unique image never to be captured again. As the saying goes "you can never stand in the same river twice"—and this is how I felt with these long exposures of water. I was capturing something that the human eye alone could not conceive. One image in particular stands out in my memory. It was the first time I captured an "invisible" eddy of water. There are often flows that we cannot see with our

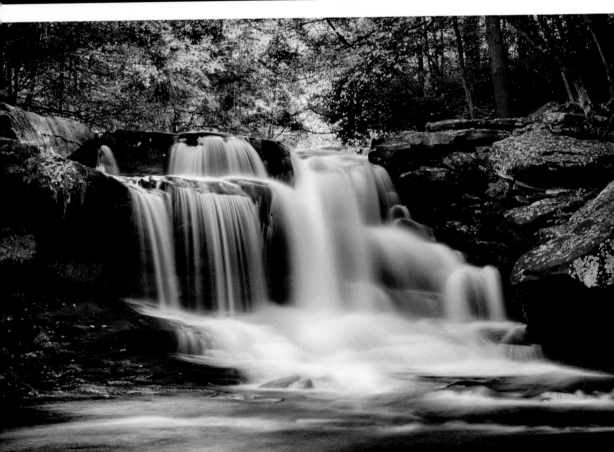

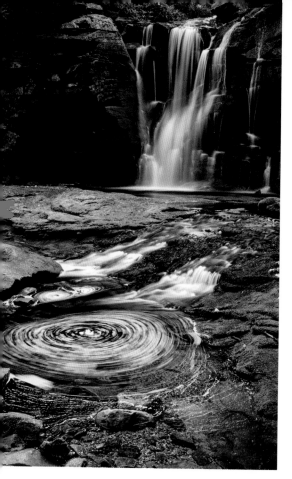

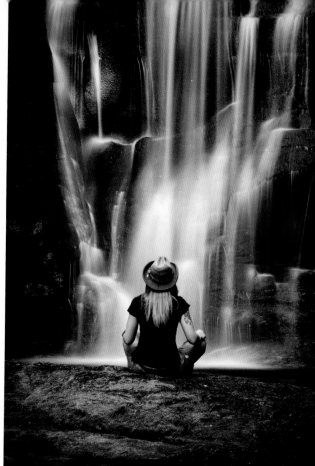

eyes, but in an image that captures a length of time in one frame, hidden gems often emerge *(top left)*.

Once I felt I had worked the extent of a scene from its entirety to small details, I would spend some time being extra creative. Often, this would mean using my tripod and timer to place myself in the scene. These are images that were just for me. The ones I knew I'd be most happy to look back on years in the future. Traveling alone, I learned the importance of taking "selfies." If you have no one else to take the photo, you've got to do it yourself. These images are going to be the ones that you'll cherish most, the memories that will hold up through the years *(top right)*.

Once I felt I had worked the extent of a scene from its entirety to small details, I would spend some time being extra creative.

Colorado

There's No Place Like Home

During my travels, I am often asked where I am from. I have Texas license plates on my car and I spent the last ten years of my life in Austin. Even when I lived there, however, I never felt comfortable calling it home. I grew up in Colorado and my heart never left. It has always been an anchor, a place to regroup, and the only stability in my nomadic life.

I visit Colorado often and during all seasons of the year. Unlike larger trailers, the teardrop allows me to travel to more remote places all year long. The winter is one of the most beauti-ful seasons to me and I didn't want to be un-able to experience it. I stayed warm in my little winter wonderland home as I photographed my favorite places in Colorado.

The Flatirons

The Flatirons are the most special feature of Boulder, Colorado—the place I called home during my college years. Standing in front of them years later, memories of my college days flooded back. I am passionate about photogra-phy because images elicit emotional responses in all kinds of ways. When I see my own images

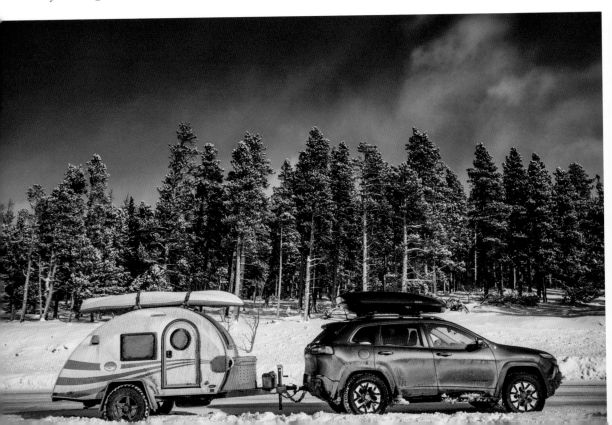

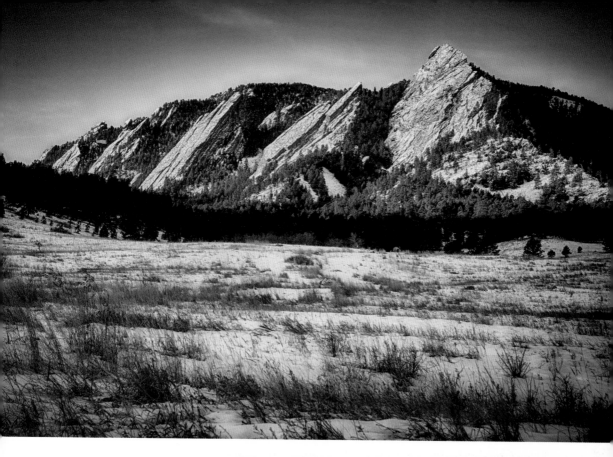

I remember my personal experiences, but when I share them with others I find that they connect in a different way that stirs their own personal memories *(above and right)*.

Maroon Bells: A New Tradition

After I graduated college, got married, and began a career, I expected life would go according to plan. In turn, many yearly traditions emerged. When life fell apart, losing every tradition I had was surprisingly hard to cope with, and a constant reminder of what I lost. I decided to establish a new tradition that combined all of my favorite things (photography, the mountains, and Colorado) by returning to Maroon Bells to photograph the very last sunrise of each year.

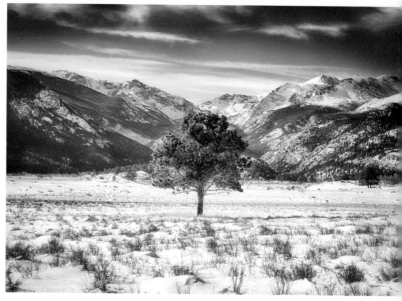

The first year I did this was a huge turning point for me. At sunrise that morning, I was the only person standing in front of the

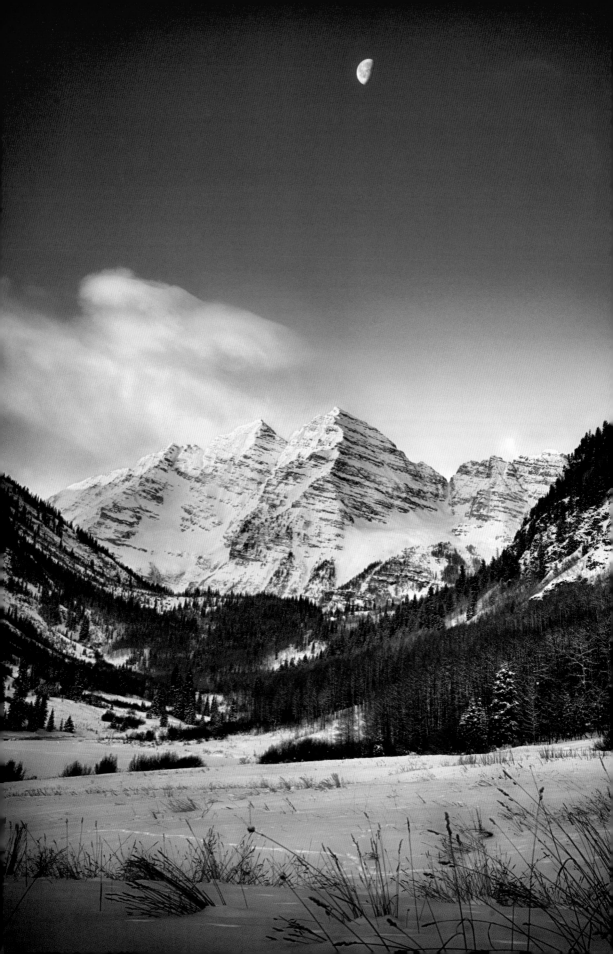

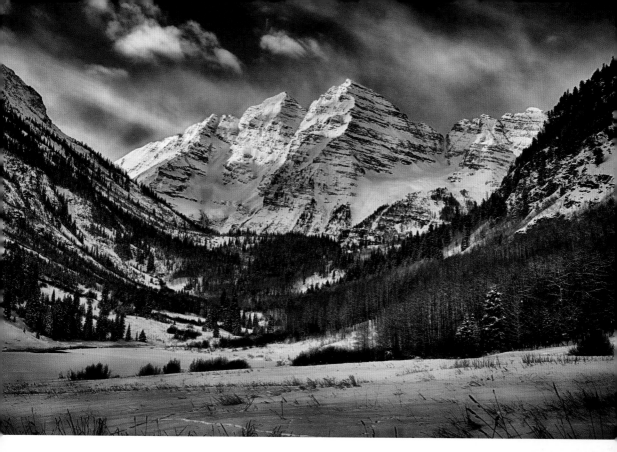

silently majestic snow-covered peaks. All I wanted to do was turn to someone and say, "Oh my goodness, can you believe this!?" But I couldn't. It was just me. I had been devastatingly lonely on the road. As I spent my very first New Year's Eve completely alone in the freezing cold, I sobbed myself to sleep in my teardrop. The next morning, I awoke with a new resolve. I told myself, "If you're going to do this, Mandy, you're going to have to be happy just being with you. You're going to have to like yourself."

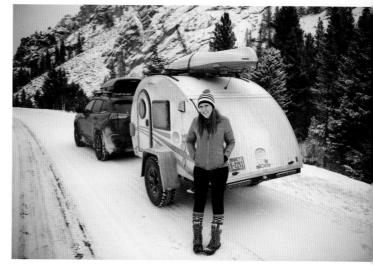

Like myself? That was a scary thought. It took months, but after a while I became content. I learned to smile and laugh even when I was all alone, and that's when I knew I had made it to a place where I was going to be okay.

I had to accept the fact that this lifestyle simply did not lend itself to meeting someone or having time to build a significant relationship. It was difficult to admit, but I resolved myself to the fact that I was putting *me* first. I might always be alone, but at least I could be happy.

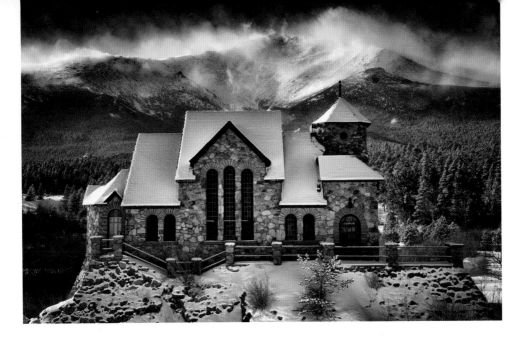

A Kindred Spirit

The world works in mysterious ways. The moment I became content within myself is the moment I met someone who would change my life. To understand my instant connection with Kendrick, you have to understand the concept of "living tiny." While I was on the road, I met many other full-timers and discovered a significant gray area between choosing to live on the road and simply being homeless. I was not living in my teardrop because I had to, I was doing it because I chose to. This takes an extreme level of dedication to living a simple life. Many people I met couldn't understand my lifestyle. When I met Kendrick, an ex-chemical engineer living in his Tacoma truck to pursue his passion of running and climbing, we simply understood each other. We didn't see one another as vagabonds, but rather two passionate individuals chasing our dreams.

Long's Peak

As with most significant events in my life, our meeting can be summed up in a photograph.

When I met Kendrick he was on the verge of completing a personal project: climbing Long's Peak each month of the year. It was December and time for his final ascent. I remember how nonchalantly he told me of his project—something I could never dream of doing! He was doing it for himself, and I admired that. He mentioned that his December ascent might not happen as it was nearing the end of the year. I told him he must do it even if I had to take him to the mountain myself! That's just what I did.

Our story began with this mountain. After I dropped him off early before sunrise, I took my camera out. I photographed this church, standing strong in front of Long's Peak *(above),* as Kendrick was headed up. Despite the blowing snow, he completed his project that day.

We spent the next several days hiking the snowy mountains of Colorado. He allowed me to photograph him—and even took the camera to get some shots of me. These photographs speak of genuine happiness, real smiles, and simple contentment *(facing page, top).*

Dream Lake

We hiked to beautiful places that take effort to photograph. Dream Lake was frozen over (*below*). Snowshoeing out before sunrise was freezing but well worth the effort. The wind was blowing so hard as I stood atop the icy lake—it was the first time I understood the true effectiveness of spikes on tripod feet!

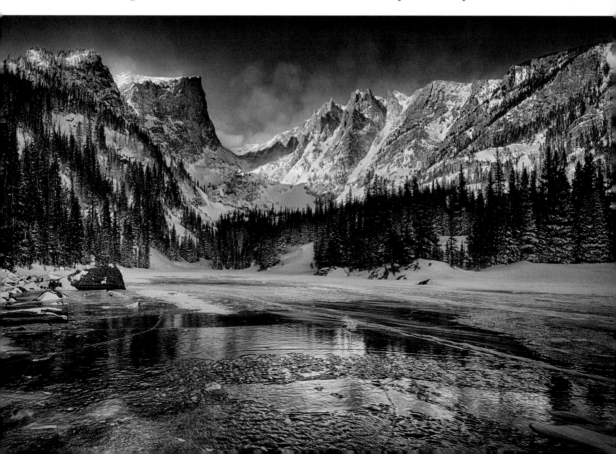

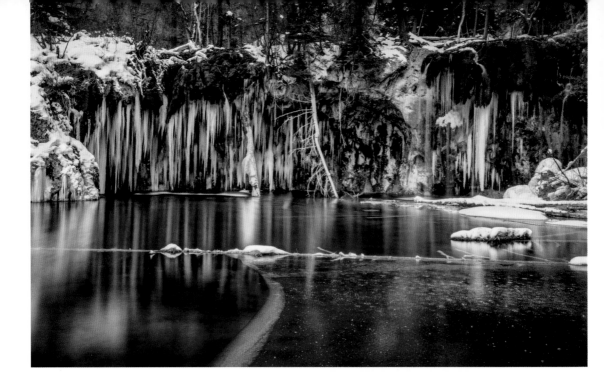

Hanging Lake

Hiking to Hanging Lake in December was a treat *(above)*. Since I love waterfalls, visiting a frozen fall in an alpine lake was beyond amazing. Landscapes are different in each season, and I try to emphasize the character of the season I am in. This is why I placed the sweeping sheet of ice prominently in my foreground.

The Flatirons: A New Memory

We stood together in front of the Flatirons in single digit weather, long after the sun had set *(below)*. Dancing in place to keep warm, my numb fingers managed to capture the scene. A long exposure captured the stars, and the mountains were lit by ambient city light. I now had a new memory of gazing at these rocks.

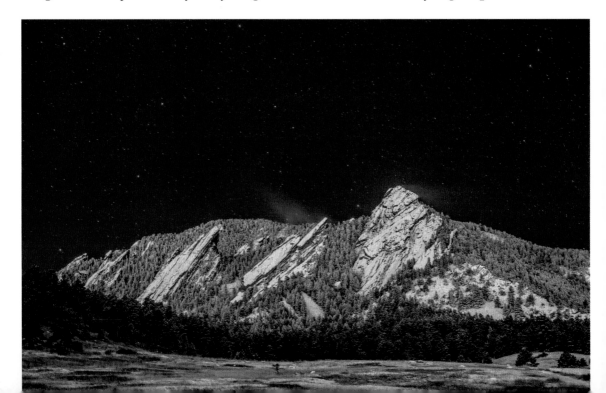

Maroon Bells for Two

It was December again, which meant it was time to continue with my personal tradition of photographing the last sunrise of the year at the Maroon Bells—but nothing said I had to do it alone, so I invited Kendrick to join me. Reflecting on my debilitating loneliness of one year prior, it was an odd yet amazing feeling to have someone to turn to and say those words, "Oh my goodness, can you believe this!?" I don't know whether it was the presence of Kendrick or just my growing skills as a photographer, but those are my favorite Maroon Bells images to date.

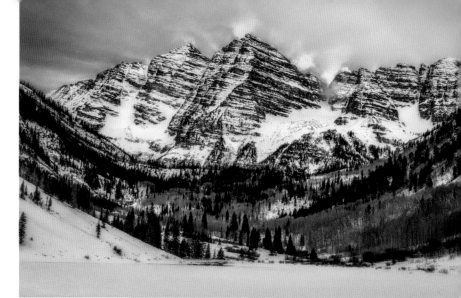

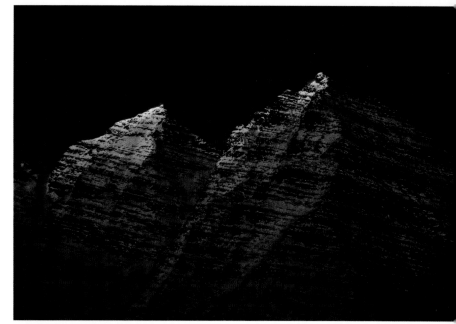

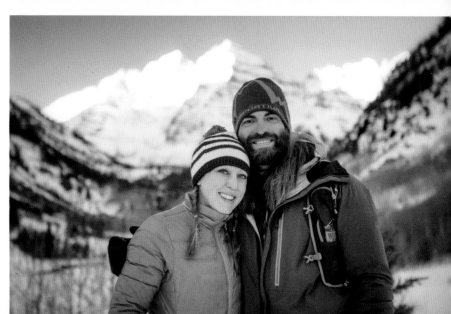

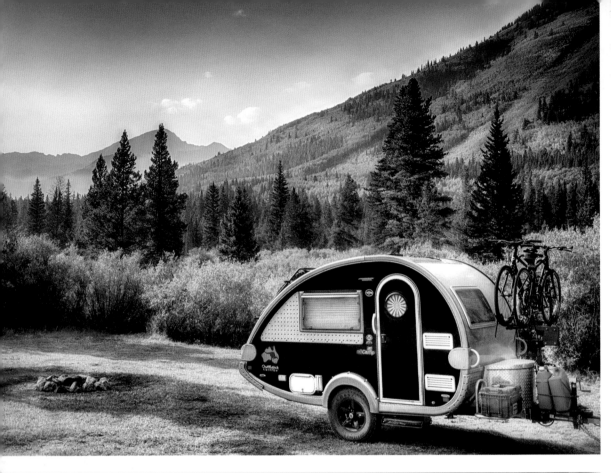

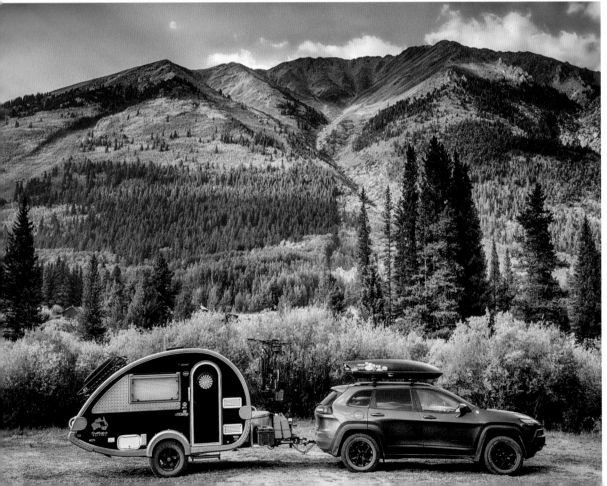

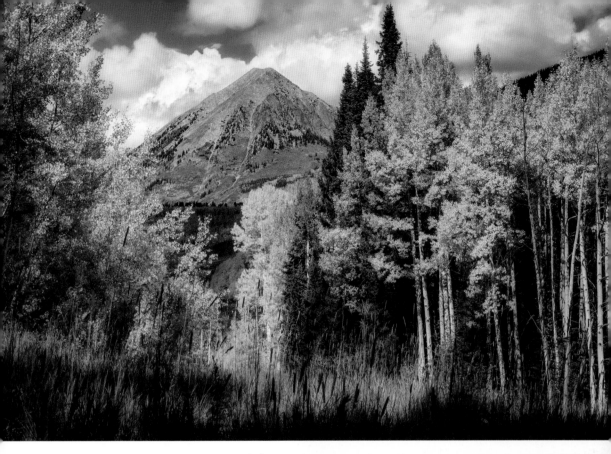

Meet Rocky

Over the years, Kendrick and I would come back to Colorado many times in our new tiny home, Rocky. While we did go "bigger," he's still pretty dang tiny for full-time living! Rocky, our T@B trailer, allows us to travel down every road we desire to travel—and that is the best kind of home.

A Colorado Fall

Colorado is a spectacular place to photograph. Unlike many regions, it has four distinct seasons, each with its own special character. After having captured the beautiful snow-laden winter, I wanted to photograph the colors of autumn as I had in West Virginia. Colorado's fall *(above and right)* blew West Virginia out of the water.

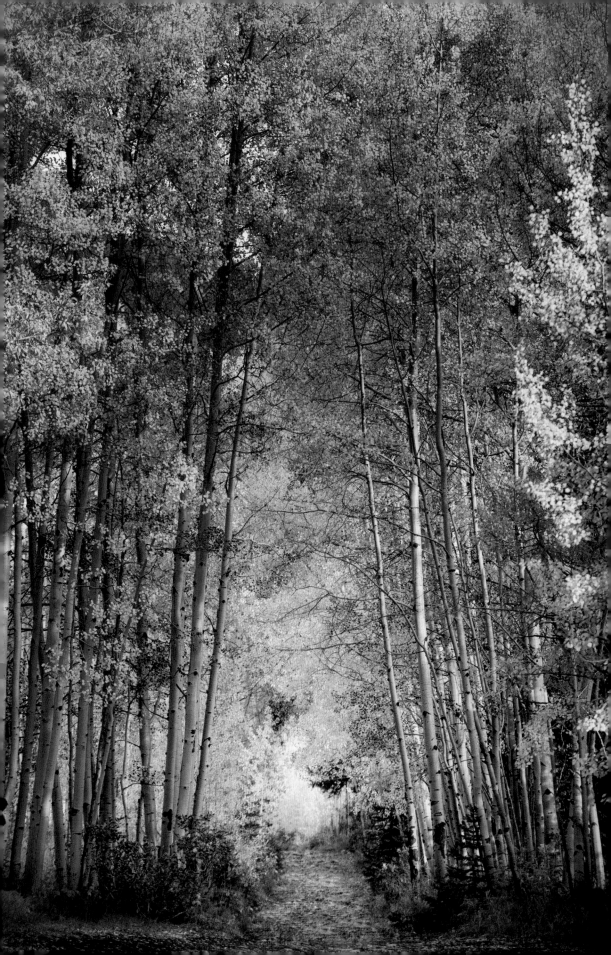

Thinking Small

In landscape photography we are often tempted to strive for the "grand shot." We look for that big, dramatic image that shows an expansive scene. In the fall, however, there are many opportunities to focus in on "micro-landscapes," smaller scenes of trees, rocks, and colors.

Many times, I arrive on a scene and am not instantly inspired. These are the moments when I begin looking for the little things—small bits of color or a window through the trees that can create a dynamic image *(facing page)*. Patterns are one of the most interesting things in nature. There are patterns everywhere that are easily overlooked. If you're ever lacking inspiration, don't forget to "think small" *(right and below)*.

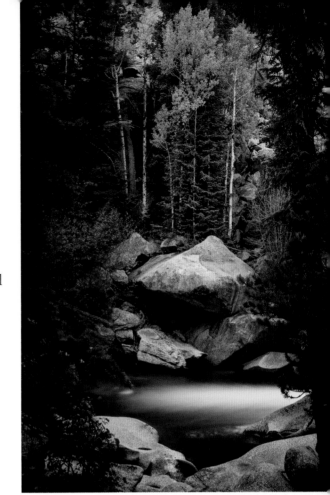

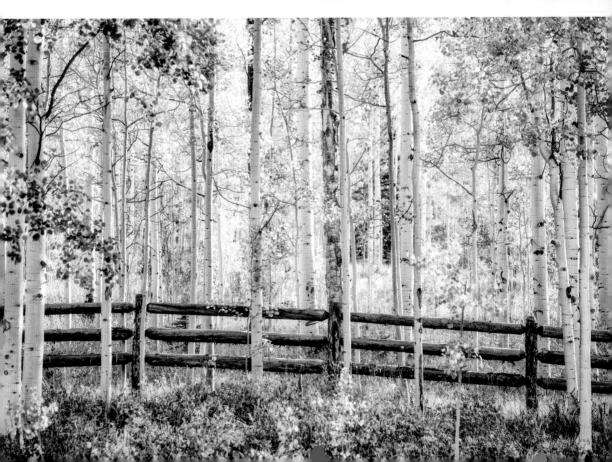

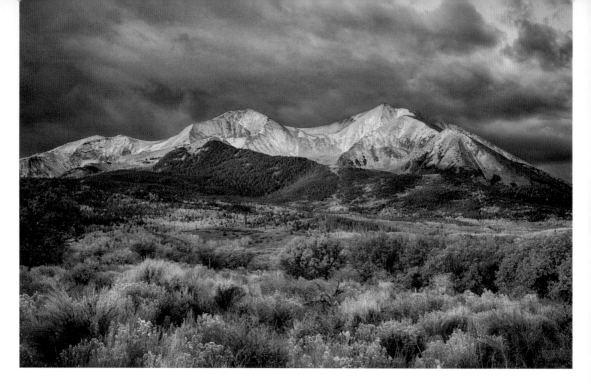

Wandering the Roads

Capturing the essence of a Colorado autumn was fun. The peak season is very short, but if you plan it right you can capture the range of greens, yellows, oranges, and reds. We drove around for days, seeking nothing in particular and stopping when the view was inspiring *(above, below, and facing page)*. Sometimes there was an old building telling the story of Colorado's history. There were roads that led your eye far into the distance. And sometimes, it was simply a spectacular view with dramatic clouds. Your passion should make you happy, and I was exactly that.

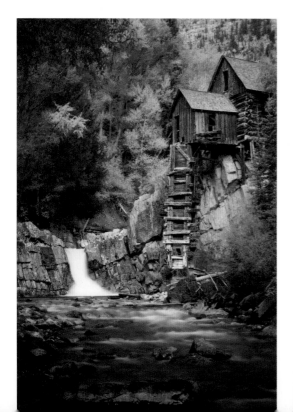

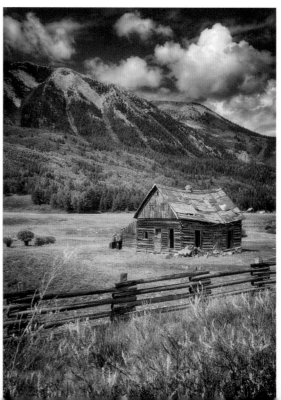

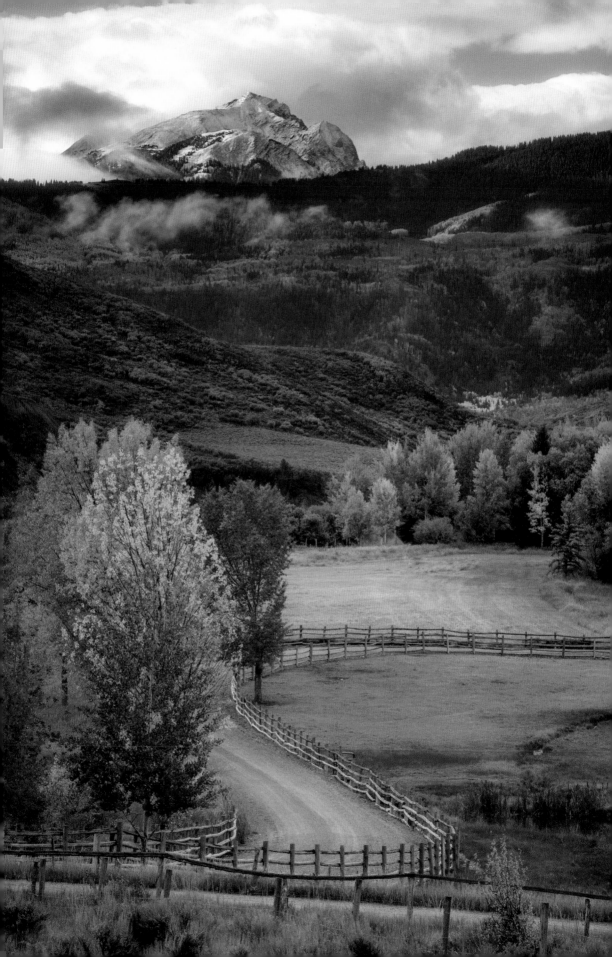

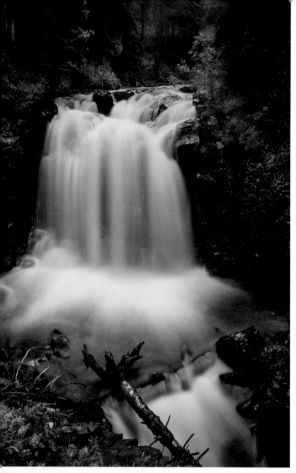

Waterfalls

Colorado is full of my favorite subject: waterfalls! I will shoot water any chance I get, and these falls were straight out of a fairy tale *(left, top and bottom)*. They were surrounded by green leaves and colorful wildflowers, and the scent of pine was strong in the air. I used my favorite technique of walking straight into the water to get my desired angle . . . but this time it was ice cold!

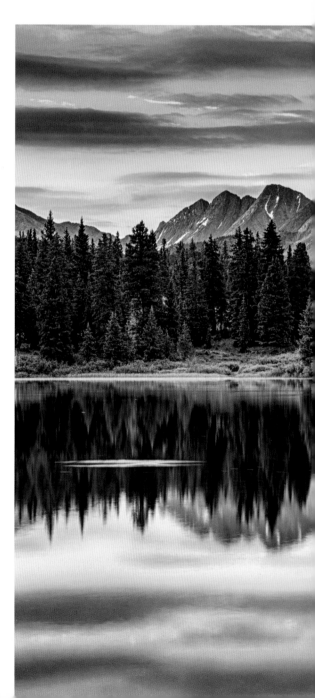

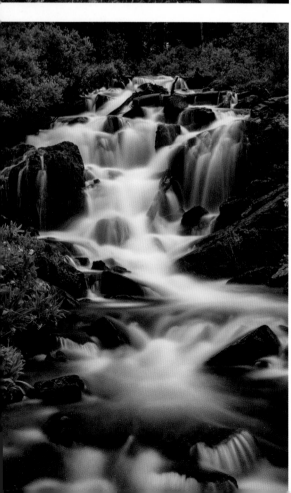

Mountain Lakes

The lakes high in the Colorado mountains *(below and right)* are unlike anywhere else. They are so blue that they hardly seem real. The lakes are a little difficult to get to, but after a long hike with a heavy pack, you really feel like you've earned the image. Plus, that means fewer people!

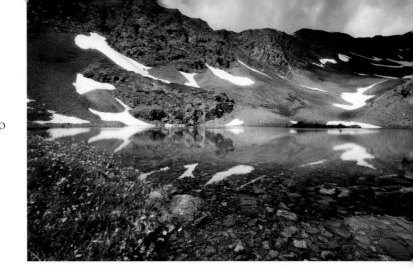

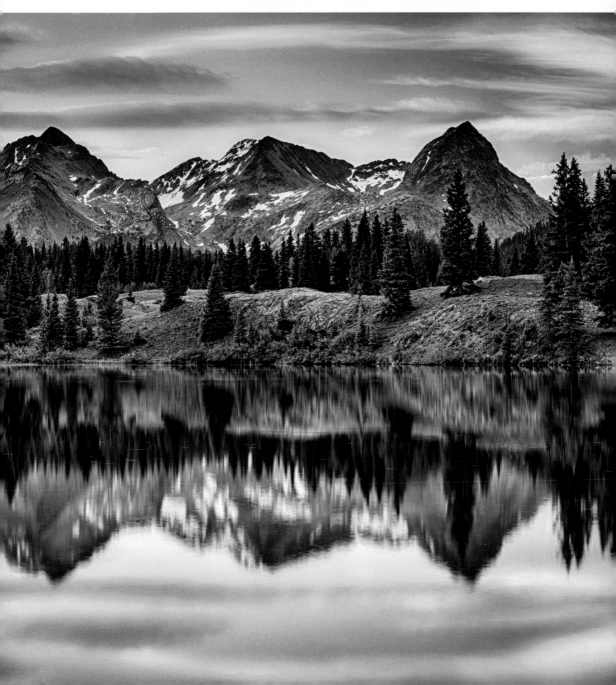

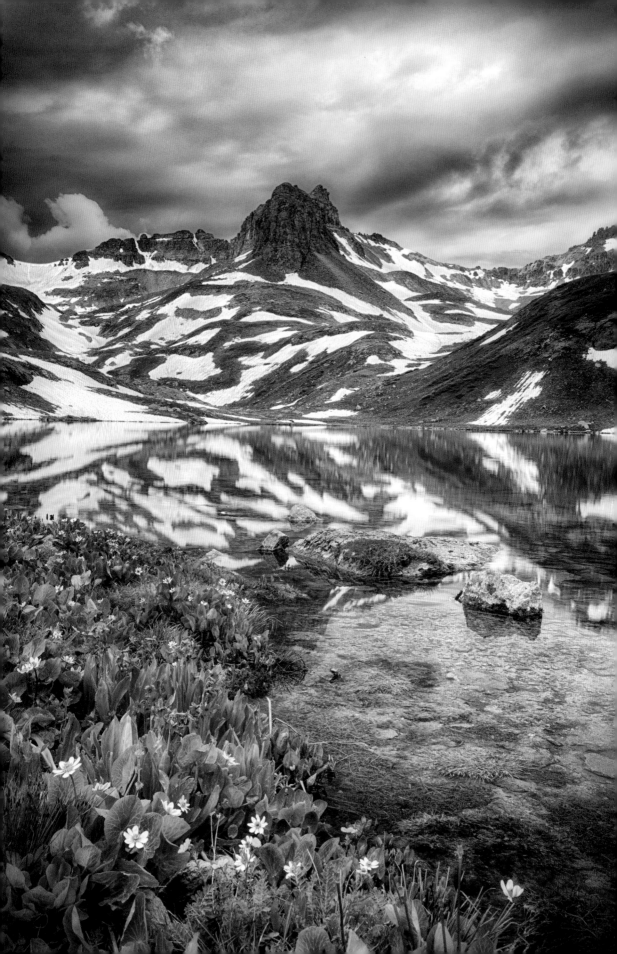

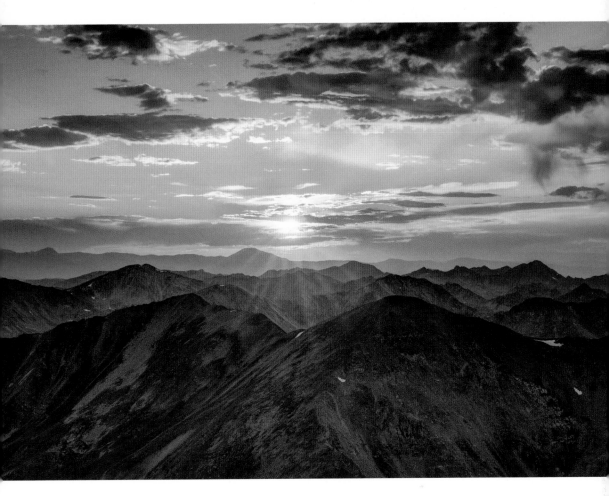

Mountain Springtime

In the mountain springtime, you can see the most wonderful combination of the last snow left high up in the peaks along with the wildflowers already blooming *(facing page)*. To emphasize this beautiful display of the changing of seasons I placed the flowers in my foreground, leading your eye to the snowy peak beyond.

Mt. Elbert

Colorado is home to 53 of the 96 "fourteeners" (peaks over 14,000 feet in elevation) in the United States. While I haven't climbed all 53, I did think it would be a wonderful homage to photograph from the tallest one in Colorado, Mt. Elbert *(above)*. As a landscape photographer, getting the image often comes before comfort. While everyone else left early in the morning to hike during the sunniest part of the day, we headed out late in the afternoon to be sure to capture the sunset from the summit. Yes, this meant we'd have to hike down in the dark, but it made all the difference in my final image.

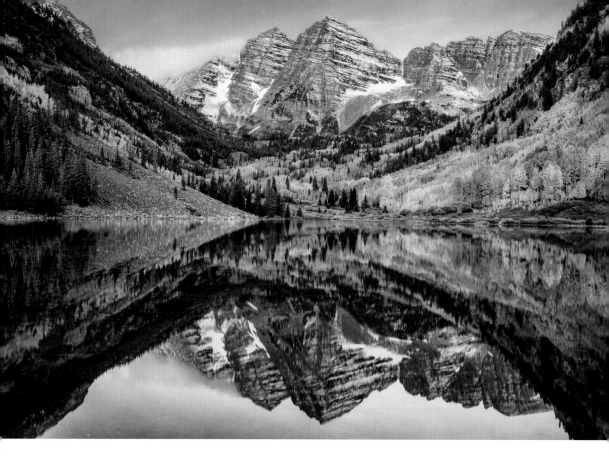

Back to Maroon Bells

In the spirit of capturing scenes in different seasons, we made a trip to the Maroon Bells in the fall. I was reminded of why I prefer to visit in the dead of winter when there is no road access and you must hike in. During the rest of the year, the Maroon Bells are flooded with hundreds of photographers at sunrise.

A very common challenge you will see throughout landscape photography is fighting throngs of crowds. With the growing popularity of social media, many of these iconic gems are becoming easier to discover and, thus, overrun. In some cases, the number of visitors is ruining the habitat and shutting them down.

I felt a strong air of competition among the photographers at the Maroon Bells. To me, art is so personal that there is no option for competition. If everyone is fighting on a different artistic battlefield, how can someone win?

I was reminded of why I prefer to visit in the dead of winter when there is no road access and you must hike in.

Traveling as Two

Traveling as two and living full time in a tiny teardrop trailer was a huge change for both Kendrick and me. We were both very independent people who suddenly entered into a challenging living situation. There was a lot of learning during the first year together. A lot. How to live tiny, how to live with each other, and simply how to live. But above all the challenges, we were happy and free from the confines of the conventional lives we hated. We were, and still are, uncertain about the future, but as long as we can look up at the stars at night we know we're headed in the right direction *(below)*.

We still had to work on the road, so Kendrick began helping me with the photography business and our work took us to many new places. We'd make sure to play a little while we were there too.

Death Valley

I try to treat my landscape images as though I am photographing a portrait of a person. I look to capture the unique characteristics that

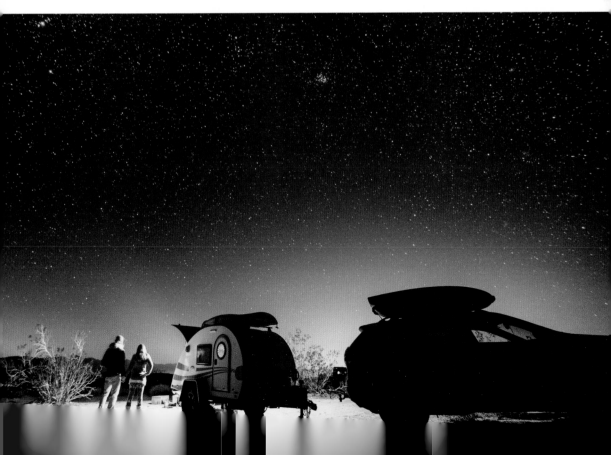

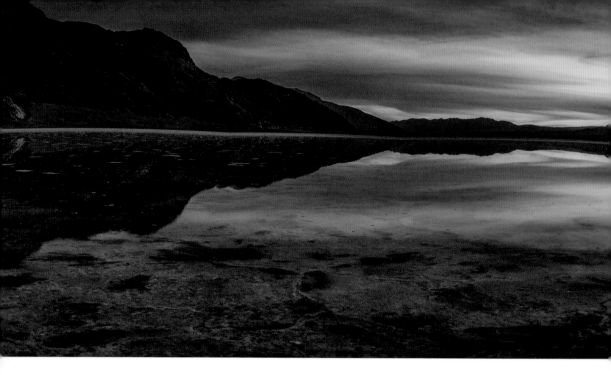

make them who they are. Landscapes are no different. I had already photographed many deserts throughout the southwest, but nothing prepared me for what I experienced in Death Valley National Park. This is a special desert.

When the weather is right, the famous salt flats will fill with rain, pooling up as if it is a giant lake, but only inches deep *(above)*. The shallow water allows you to see the texture of the cracked earth beneath.

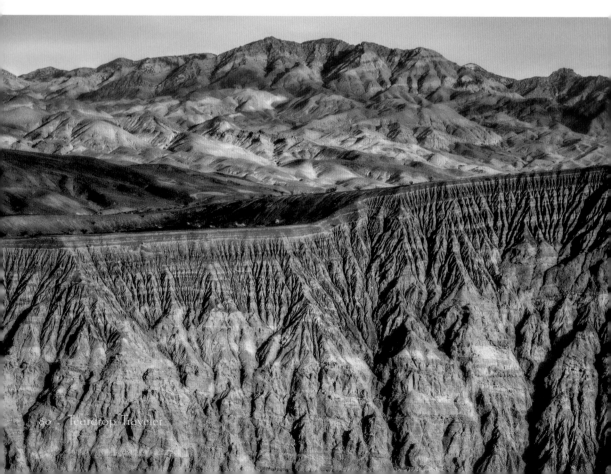

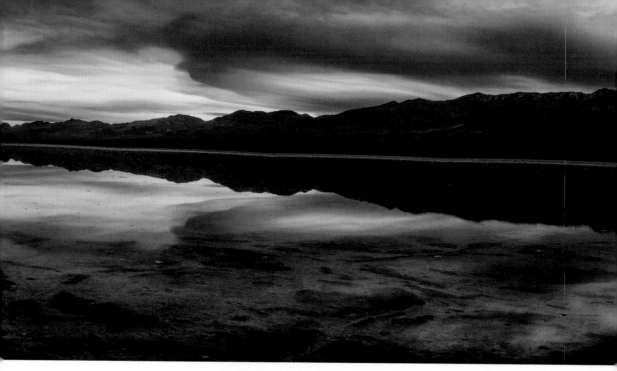

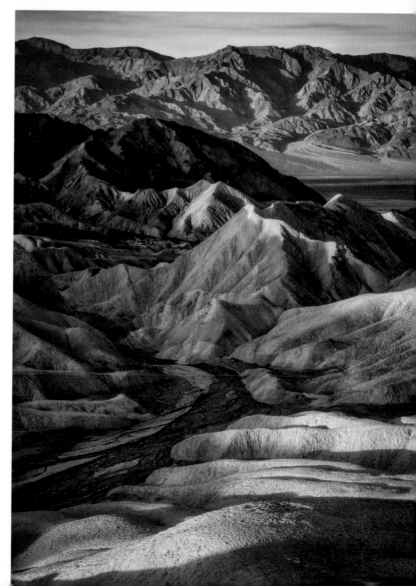

There are many colorful mountains out there, but the ones in Death Valley are called "painted" for a reason *(right and facing page bottom)*. If you manage to photograph them during sunrise or sunset, you can bring out the vibrant colors in the rocks. The layers seem to go on forever, allowing creative compositions with leading lines and extreme depth.

Every sunset I experienced in Death Valley was vibrant and beautiful *(next two pages)*, but they happened very quickly! It was important to be set up and ready to shoot when that minute of magic happened. I've found this to be the case with many sunrises as well.

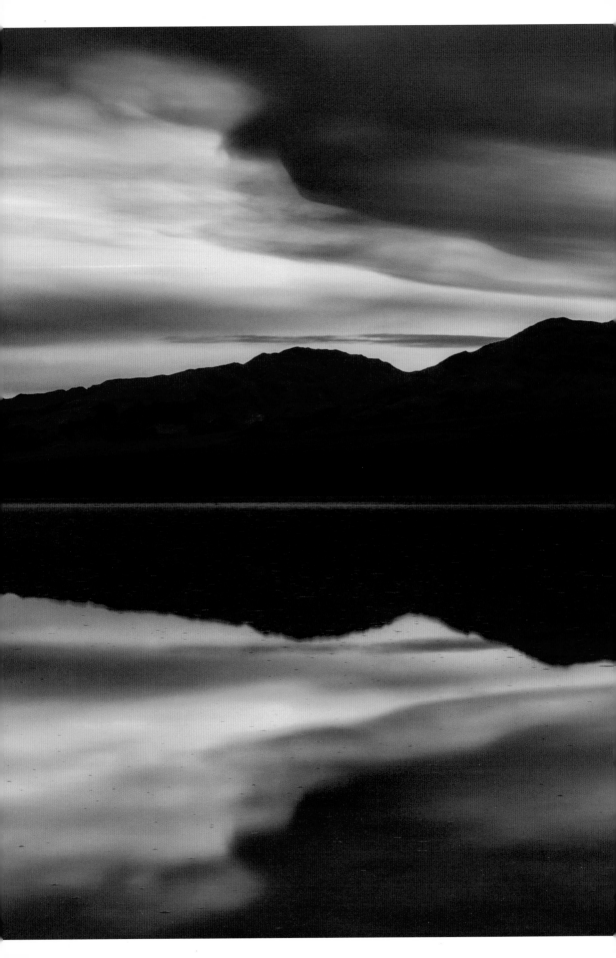

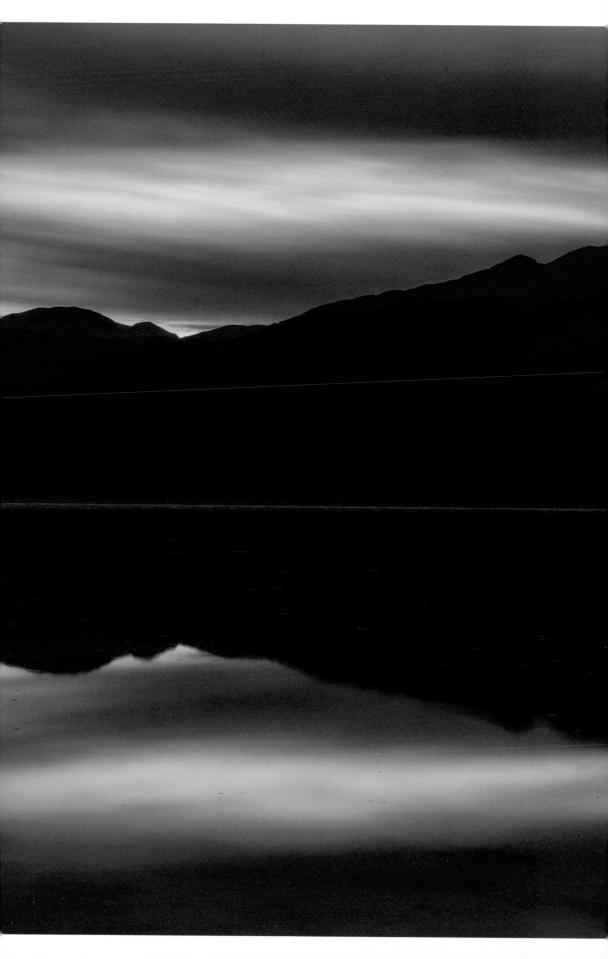

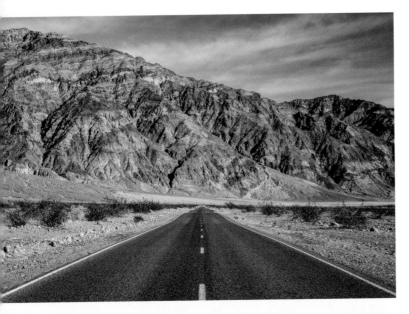

After shooting obvious compositions during the golden hours, I try to challenge myself to be creative. It's difficult to shoot in the middle of the day, but it's not impossible. I look for lines and shapes that don't require the sun and shadows to be interesting. Roads are a fun subject as they are almost always interesting. By nature, roads take the viewer's mind into the image and make them imagine where they are going (*top left*).

The middle of the night affords a photographer hours of uninterrupted time to play while it's dark. I went out on a clear and starry night and found myself surrounded by silhouettes of gnarly plants (*bottom left*). I can shoot stars almost anywhere, but these rooty trees were unique. I used my headlamp to add just enough light for a little drama.

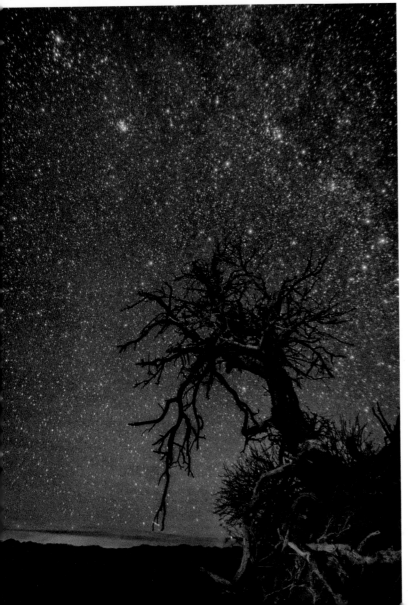

Smoky Mountains

Our pursuit of offering a variety of workshops led us scouting deep into the Great Smoky Mountain National Park. I was amazed at the variety of photo opportunities within this one park. There is everything from wildflowers and wildlife to large vistas overlooking endless hills—and my personal favorite: all the

waterfalls you could possibly want! Seeing all of this park would definitely take many visits over the years.

Being a landscape photographer and always outdoors, you would think I'd photograph a lot of flowers. While I do enjoy pulling out my macro lens, it takes a very special flower to get my attention long enough to shoot it. I can tell you I spent a lot of time on my knees

in the Smoky Mountains, crawling to the most perfect wildflowers *(below)*. At first I just photographed the ones I thought were cute; over time, I began to learn their names. Photography has taught me a lot of things I never imagined I would learn.

It was one of the most green and lush places I've ever seen, a stark difference from the deserts of the west I had been spending time in.

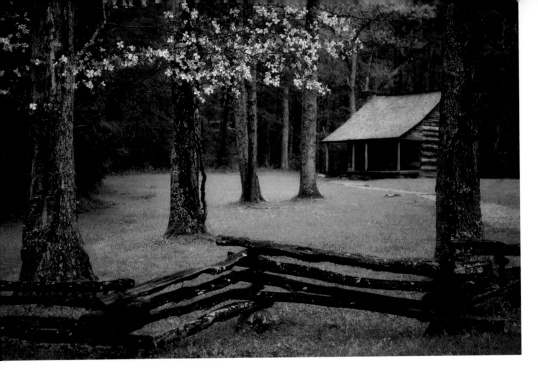

Everywhere you looked, something was growing or blooming. I photographed the famous flowers on the dogwood trees. Often the trees surround the old cabins and roads, reminders of the population that once occupied the area *(above and below)*.

And the moss—oh, that beautiful moss! The most vibrant green color lines each of the many flowing rivers. The cascades and falls are framed in a soft blanket of moss, adding texture and color to the scene *(facing page)*.

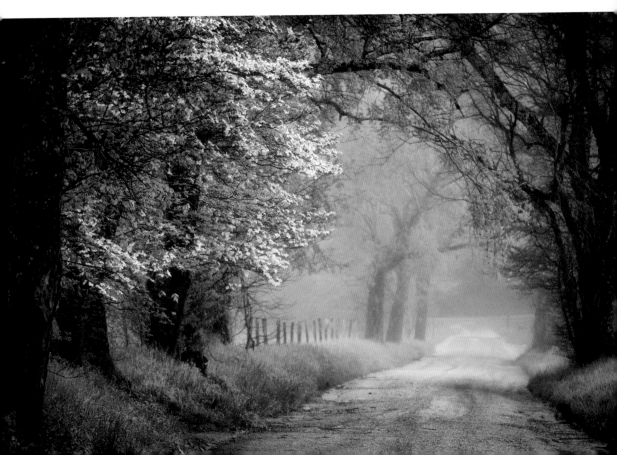

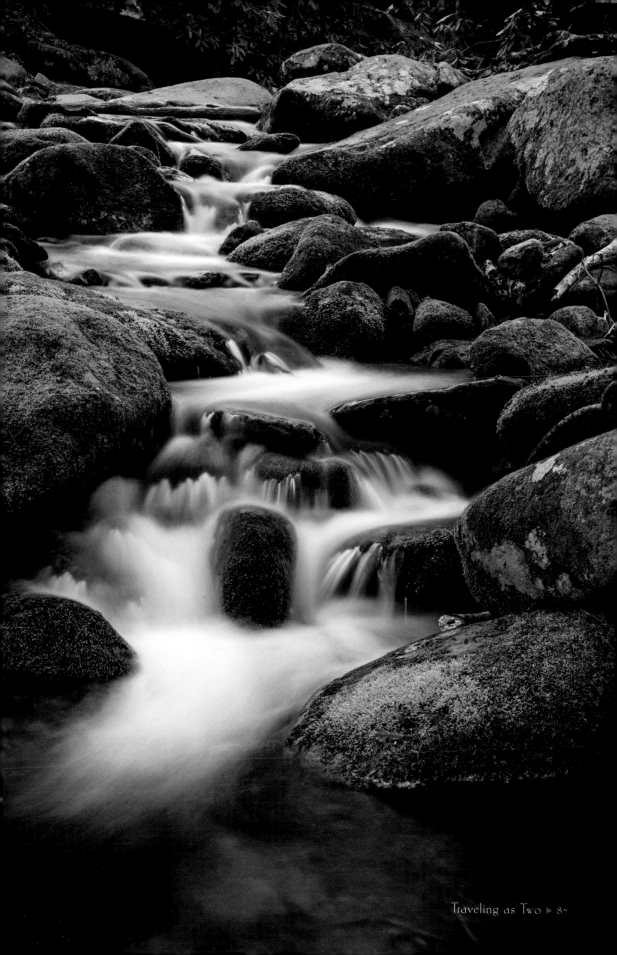

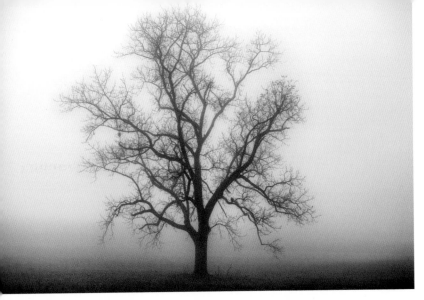

Even without leaves or blooms, the trees demand attention. If you visit the famous Cade's Cove early in the morning, there is almost always a layer of fog creating an atmosphere so peaceful you don't want to do anything more than whisper *(top left)*. If you watch long enough, the plentiful wildlife will grace you with their presence *(bottom left)*.

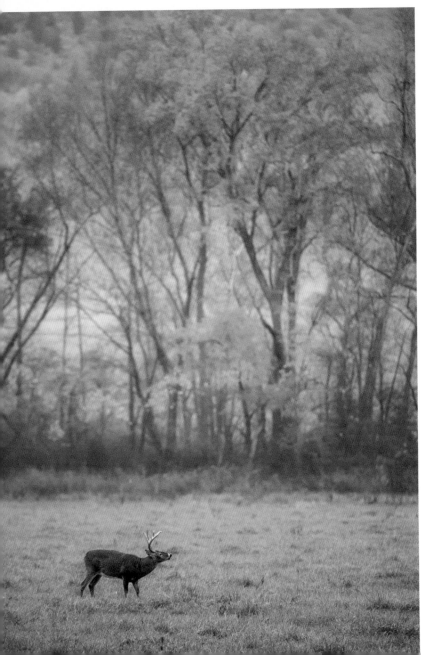

The spring gives you dogwood blooms and wildflowers, but the fall provides spectacular changing leaves. I wanted to show that this isn't just any fall, it is fall in the Smoky Mountains. For one image, I placed some bright red foliage in the foreground of a classic Smoky Mountain view *(facing page, top)*.

For another fall image, I revisited my favorite waterfall in the park *(facing page, bottom)*. I have photographed it in different seasons and at different times of day. During this particular visit, I was able to capture the golden yellow leaves along with the fallen red leaves on the rocks. When I create an image, I am creating a piece of art. If a painter would paint leaves exactly where they want

them, why would a photographer not place leaves exactly where they want them? Always be aware of every inch in your image. If you can improve the shot without harming or disturbing nature, you can often add interesting elements—or remove distracting ones!

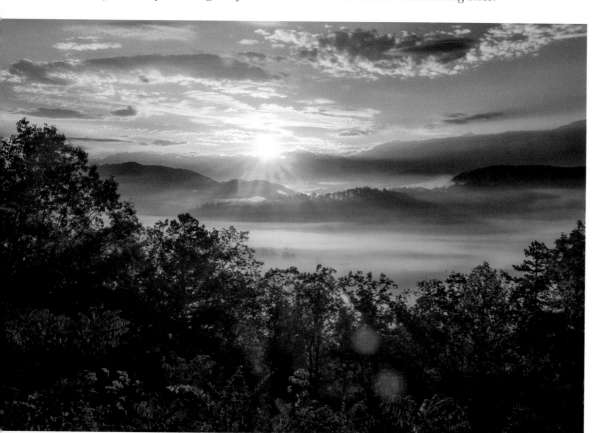

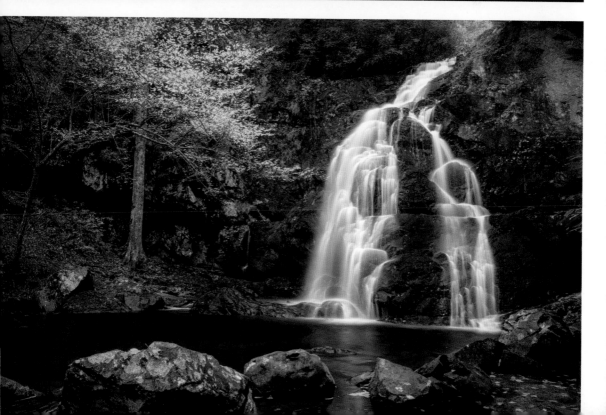

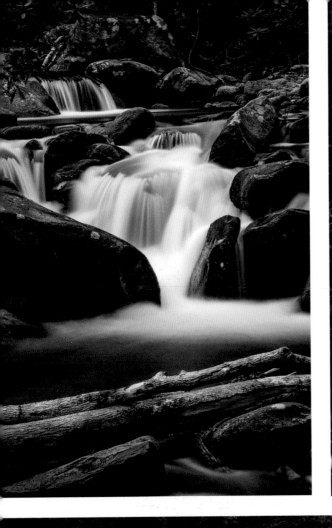
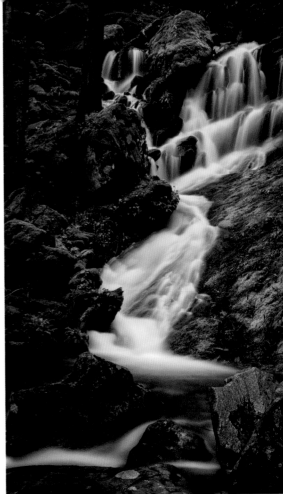
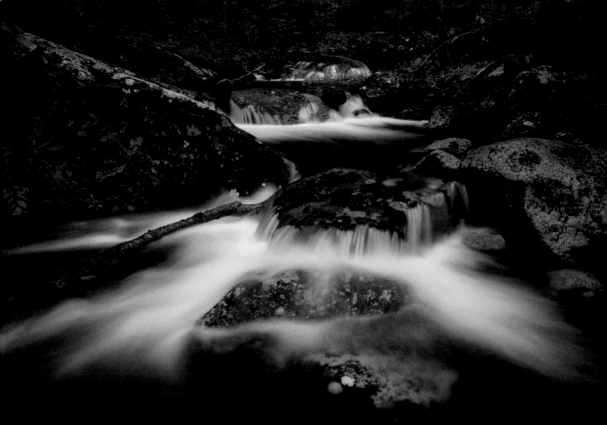

It's no secret that waterfalls are one of my favorite subjects. The reason is only partially about the result; I do enjoy a nice waterfall image, but even more than that it's about the experience. Photographing a waterfall is truly a sensory experience. I stand in the river and feel the cold water rush across my feet. The loud roar drowns out all of the noisy thoughts in my busy brain. I can smell the lush plants to which the water is giving life. And I bring my vision to life through my viewfinder (*facing page*). Depending on where I am, I may even grab a small sip!

If you prefer shooting larger vistas, you don't have to look far to capture the namesake of the park: the "smoke" in the mountains. With mountains in every direction, there are spectacular view at both sunrise and sunset (*below*).

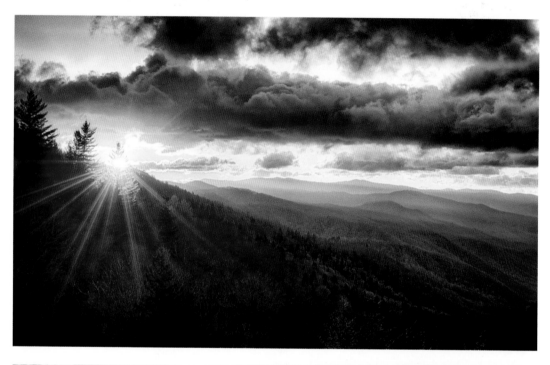

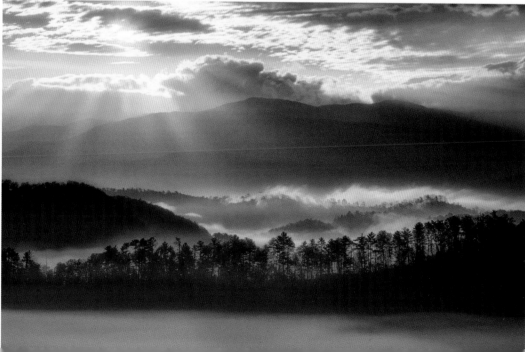

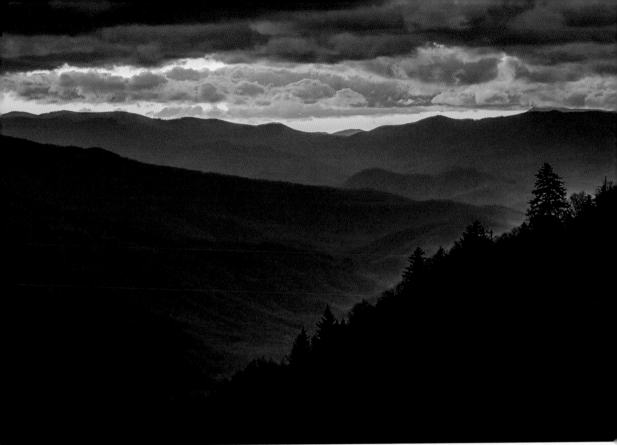

The clouds roll in and out of the hills quickly, constantly changing the view. Here I learned it is important not only to come early, but also to stay late. The scene is beautiful through sunset and even beyond. Sometimes there will be a post-sunset burst of color, leaving a moody silhouette of the trees *(above)*. It is easy to understand how one could visit this park every year and never tire of shooting it. The weather changes and the seasons come and go. Even the sun appears different as its distance from the earth varies *(right)*.

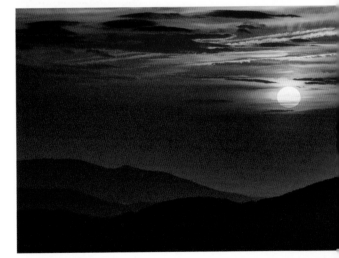

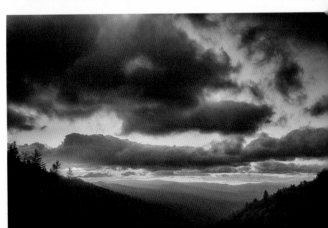

Most people sat in the warmth of their cars, but a few brave photographers stood out among the clouds.

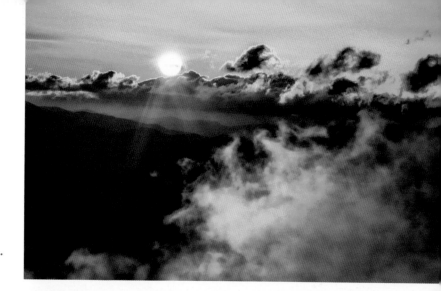

High above the clouds, the wind blows frigid cold air. This is often where we get lost in the best of our work, experiencing the moment *(top right)*. On this particular day, my eyes were watering from the cold and my fingers could barely operate the buttons on my camera. Most people sat in the warmth of their cars, but a few brave photographers stood out among the clouds.

My resolve to capture memories of myself did not change when Kendrick joined me—it may even have grown stronger! We chose a place that emphasized the spirit of the park. Using my well-practiced tripod and timer method, we captured a memory just for us *(bottom right)*.

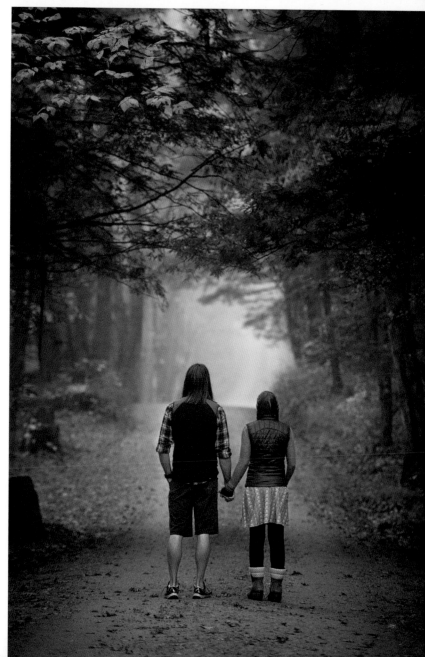

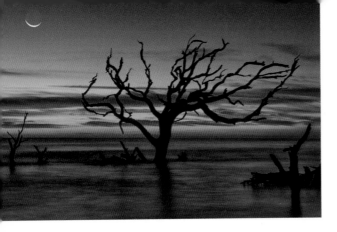

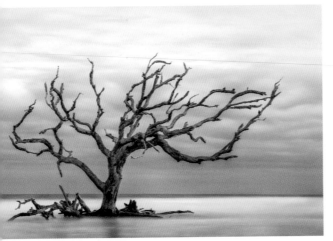

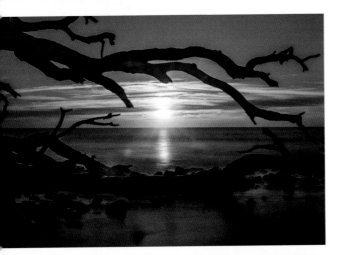

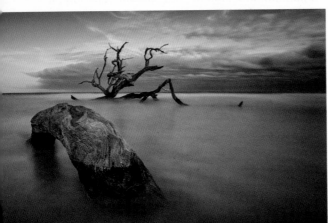

Georgia

While we have plenty of jobs that keep us on a schedule, living on the road allows us freedom between those jobs and presents opportunity for spontaneity. As we were driving through Georgia, I remembered reading about a place called Driftwood Beach *(left and facing page)*. I looked it up and saw it was near our route. With a few hours to kill around sunset, it seemed like a good place to stretch our legs. Don't get me wrong, not all of our spontaneous decisions yield great results, but this one is near the top of the list.

As the name suggests, we arrived at a beach full of driftwood. The tide was high and there was one tree that stood out among the others. I was able to use a neutral density filter to take a long exposure, creating soft and smooth water out of which this lifeless tree now stood. I couldn't get enough of the scene. I took my shoes off and worked, feeling the sand between my toes. Every minute the light was changing as the waves swept over my feet. It was a memorable sunset, and I just had to see it at sunrise.

It's times like these when I am grateful for making the choices that got me here. Kendrick was equally inspired by the beach, and so we slept nearby in our teardrop, planning to return again at sunrise. We arrived early and sipped on mimosas as we waited for the sun. It smelled of salt in the air and there was a slight but bearable chill. When the sun peeked out, we both grabbed our cameras and immersed ourselves in shooting.

People tell me they visit the same places as I do, but their images don't look anything like mine. I ask them, "Did you wake up early

for sunrise? Did you make sure to visit when the tide was high? Did you bring your tripod, filters, and set up your composition?" "No," they say, "I just drove there and got out of the car and took a picture." This is a conversation I have had many times, regarding many places.

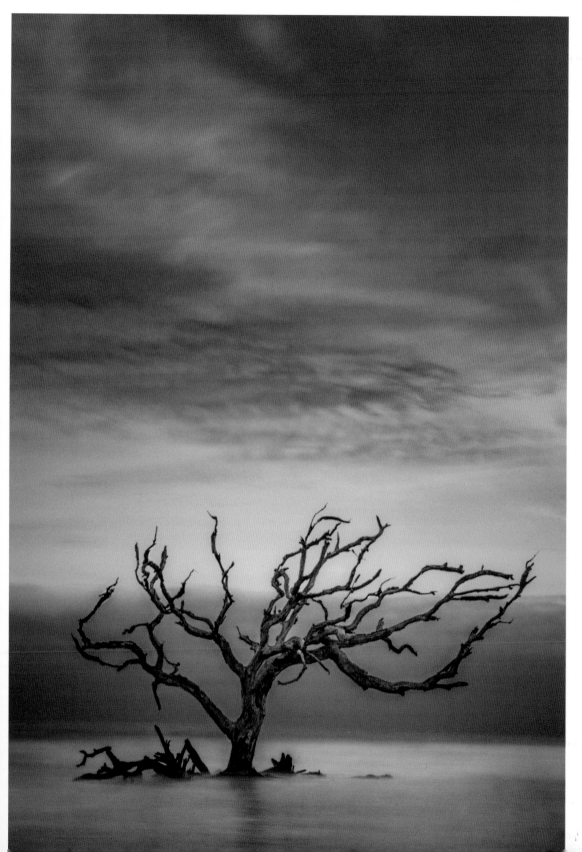

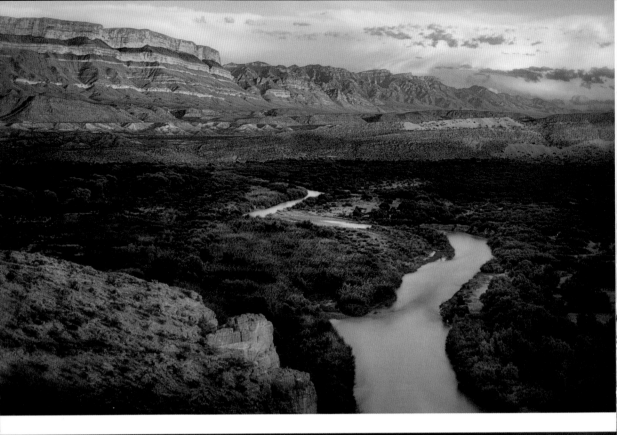

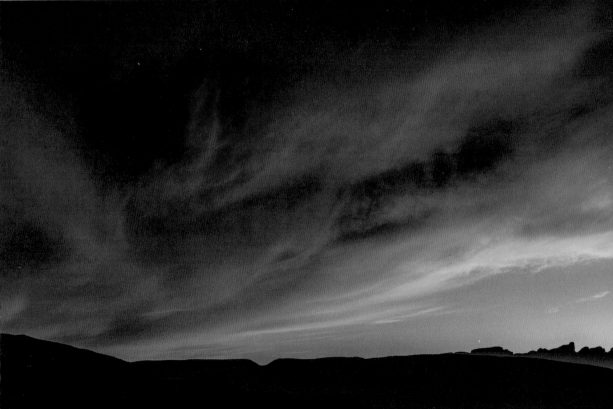

Back to Texas

I have a bit of a love-hate relationship with Texas. It is the place I was most miserable and depressed. The place I hit my rock bottom. But it is also the place I found the strength to turn my life around. The place I found my passion and began chasing it. Whether I like it or not, I left a little piece of my heart down there.

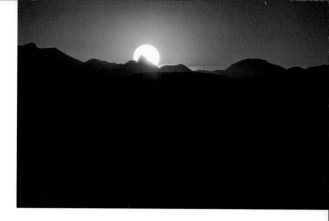

West Texas was where I held my first photography workshop. It's a huge space with few people, so it's easy to feel alone. Kendrick was convinced there wasn't a good thing about the state, so I couldn't wait to show him some hidden gems *(this page, facing page, and following three pages).*

We've held this workshop for many years now. Each time, we revisit the same places and always scout a few new ones. It's interesting after you have shot a location year after year. You begin to look for new ways to capture it. It's a wonderful challenge that helps us stretch our creative muscles.

I can see a marked improvement in my photography over the years. We evolve as artists and our tastes change. I've been able to watch my style evolve and become more refined.

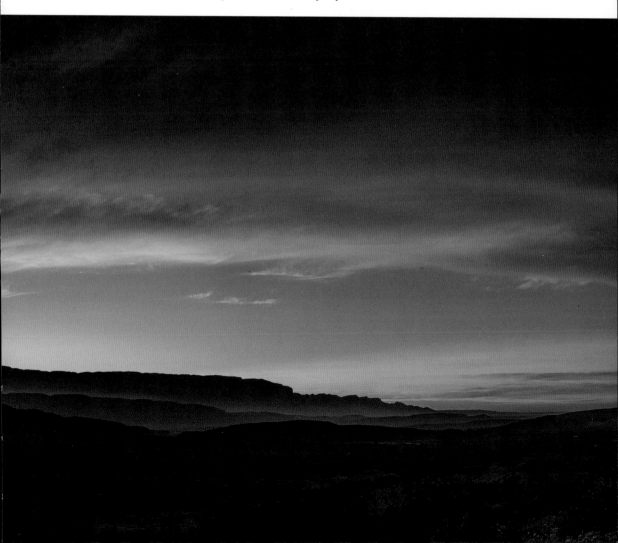

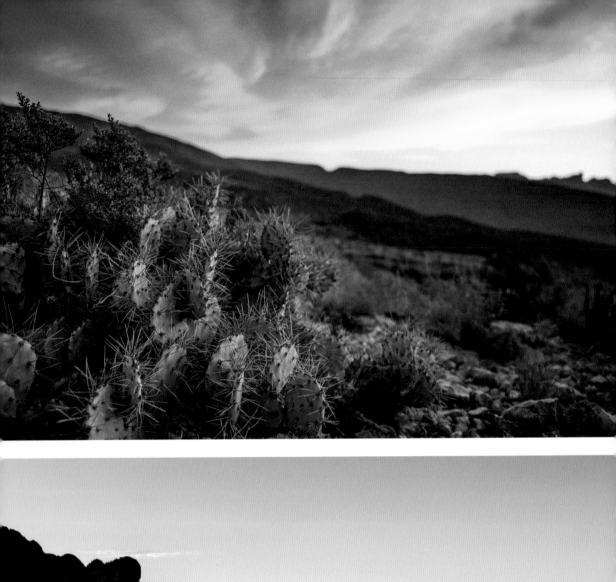
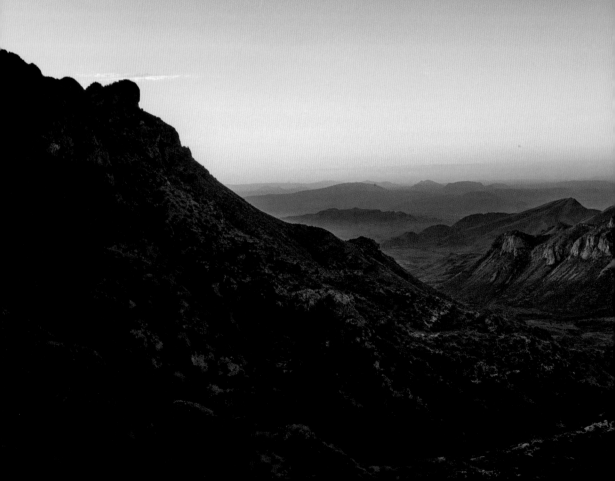

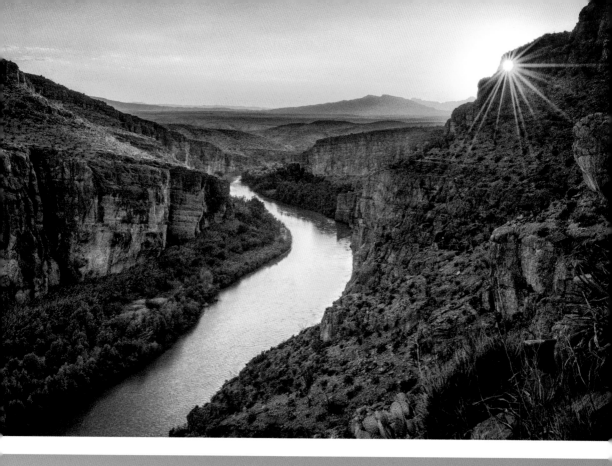

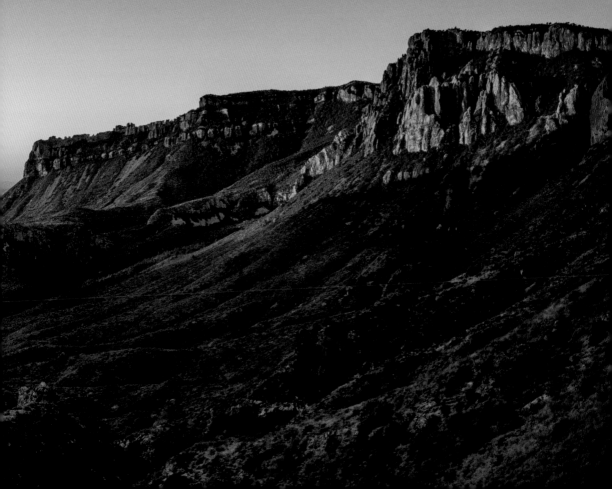

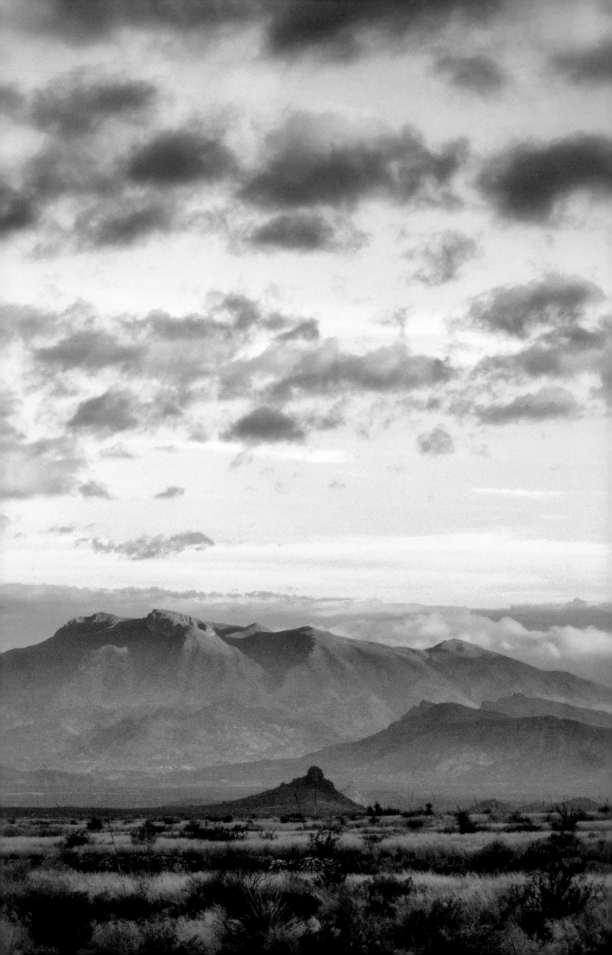

When I shoot a photograph, I can now see in my mind how I want the final image to look. I can shoot with more intent and shoot fewer frames to get the one I want.

These more recent images *(previous three pages)* better showcase the traits I see in the West Texas desert. The rise and set of the sun on the layered horizon, the way the Rio Grande snakes into the distance, creating a beautiful border between two countries, and the cactus bringing life to a desolate landscape.

I also became more practiced at photographing stars. Luckily, the dark sky of west Texas is a prime location for astrophotography. One of the difficult things about photographing stars is going beyond simply shooting the sky, but also including something related to the landscape you're in. I made a point to showcase Texas by silhouetting desert plants *(below, top)*, including the ridgeline of the distant mountains *(below, bottom)*, and lighting the cracked desert ground in front of me *(next page)*.

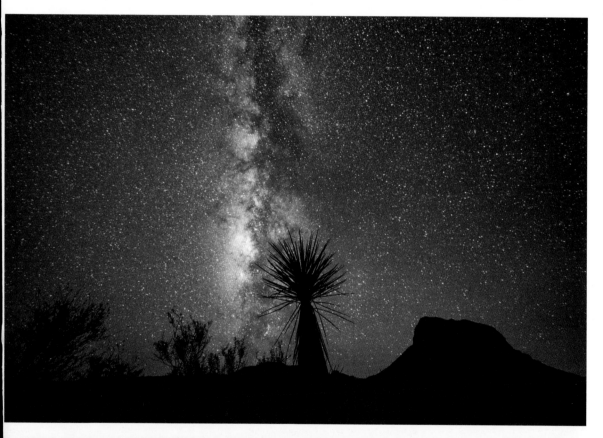

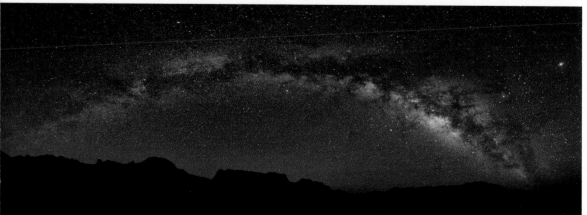

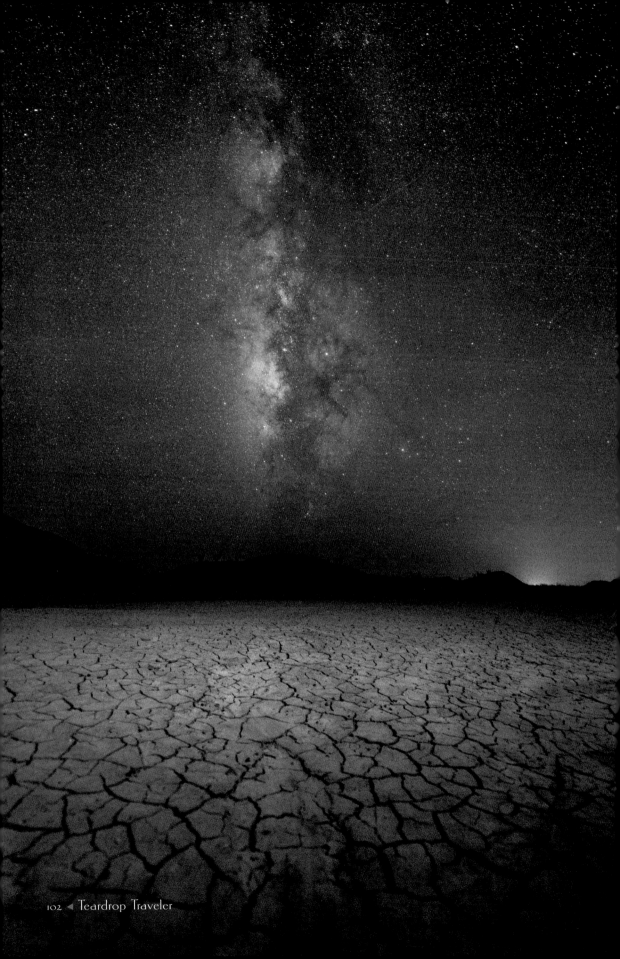

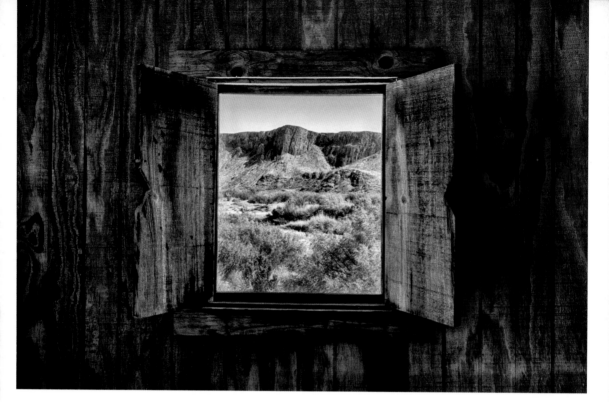

Each year I visited, I would take note of a particular window that was part of an outdoor porta-potty. I never photographed it (I was in the bathroom, after all) but I always thought how nice the landscape looked through the rustic wood frame. It itched at me so many times that I eventually took my camera and tripod to the bathroom and got my shot *(above)*.

If I were to describe west Texas, I would say it is vast and empty. The roads go on further than your eye can see, and you wonder how far the nearest human is *(below)*. It doesn't appear to be photogenic at first glance, but if you go into it with an open mind and a photographer's eye, you will find life in the land.

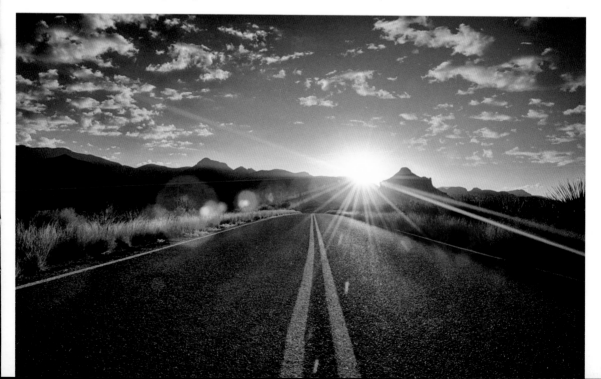

Grand Canyon

An 85-Mile Photographic Journey

Kendrick brought many positive changes to my life when he joined me on the road, but by far the most valuable is his encouragement to do things I never thought I could. This encouragement affects my life in many ways. Physically, I am able to accomplish things I never would have attempted on my own; emotionally, I believe in myself more than ever. Indirectly, this transferred into my photography, allowing me to capture moments I never dreamed I would see. One accomplishment that stands above the rest is our journey through the Grand Canyon.

Hike to the Bottom

Millions of people visit the rim every year, but only 1 percent make it to the bottom of the canyon, and only a very small fraction of that 1 percent leave the main trail—but that's just what we set out to do. We backpacked 85 miles through the most remote areas of the canyon. We saw less than ten people over two weeks as we explored areas so beautiful I can hardly describe them.

Kendrick told me to take whatever camera gear I felt I needed and he would help me carry it. While I pared down my usual setup quite

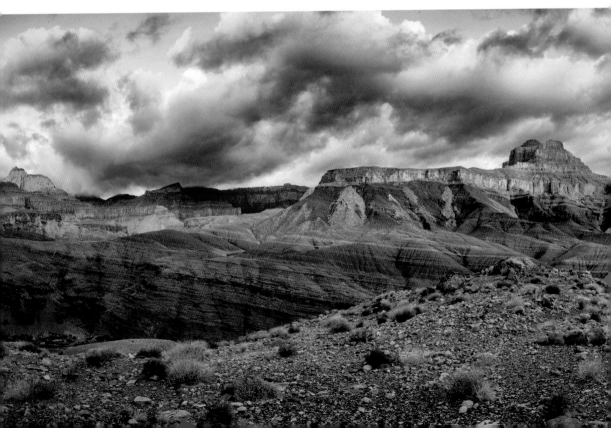

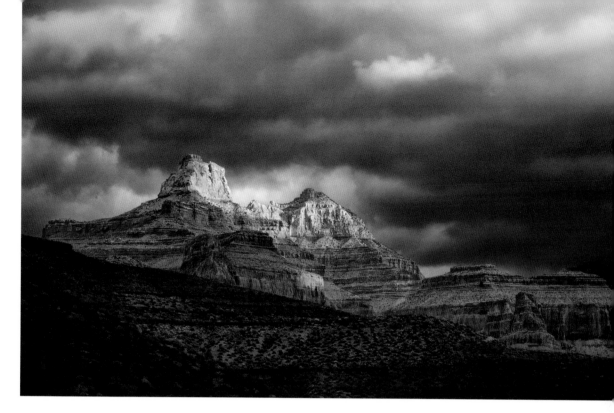

a bit, it was still incredibly heavy in terms of backpacking weight. It was a sacrifice we were willing to make to walk away with these images.

Every step of the way was remarkable. The entire first day, I was in awe at the sheer size of the walls around me. The grandiose landscape surrounding me put life in perspective. It reminded me just how small we are, and in turn my problems felt much smaller. This is a huge world and there are much bigger things going

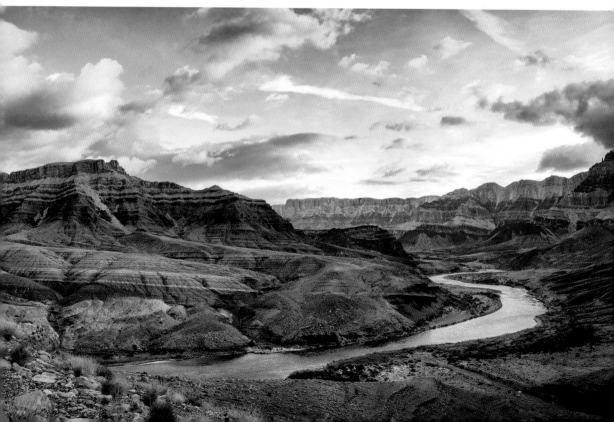

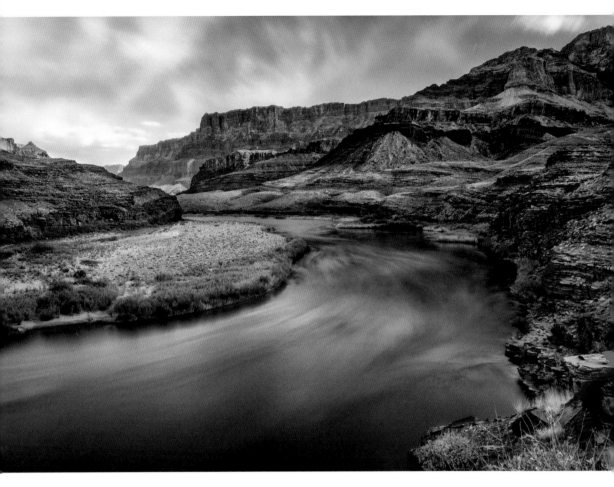

on around us than our tiny brains can imagine. I tried to convey this size by creating panoramic images and photographing the canyon walls that were most prominent.

A Different Sun

The light in the canyon reacted much differently than the sun I was used to. There were dramatic effects on the canyon walls all throughout the day. I was not limited to the normal sunrise and sunset shooting that I was used to, but would often find inspirational shots in the middle of the day as the weather rolled in and out of the canyon (*facing page, top*). Even during the rainstorms, I pulled out my camera and created a black & white image (*facing page, bottom*).

This is a huge world and there are much bigger things going on around us than our tiny brains can imagine.

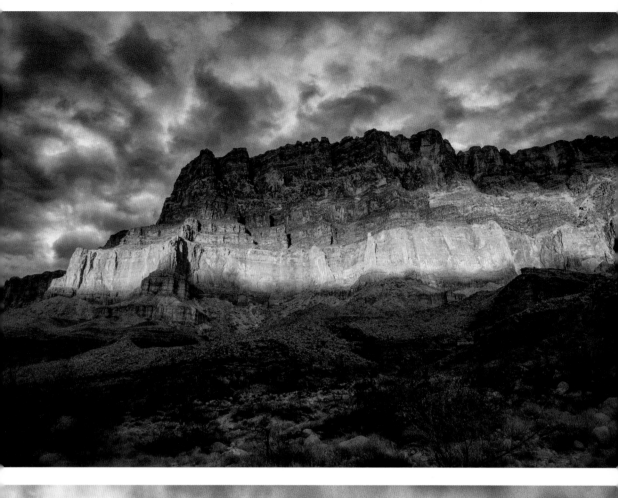

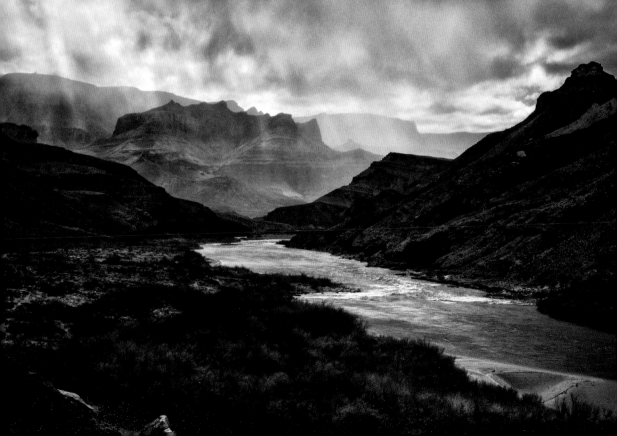

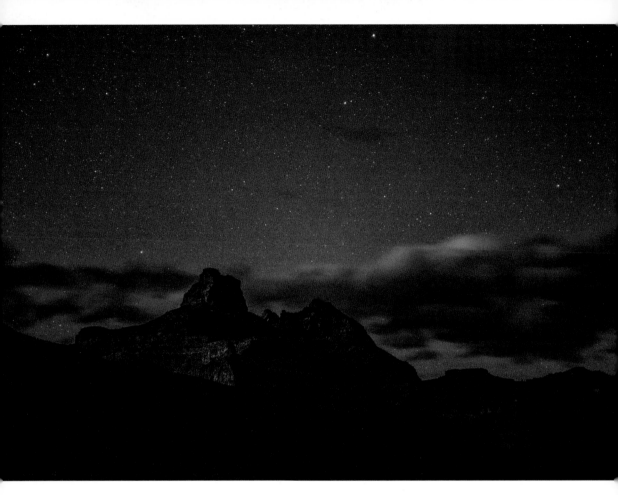

Last Light

The nighttime was magical. With a lack of any light pollution, the stars were brighter than you can imagine. Since the canyon walls are so large, it wasn't practical to attempt light painting on them. Instead, I photographed the stars at dusk and caught the very last of the light reflecting off the atmosphere onto the canyon walls *(above)*.

Desert Life

The canyon was a desert full of cactus and thorny bushes. There was very little wildlife or lush greenery to speak of. For these shots, I switched to a shallower depth of field to bring focus onto the green plant with subtle reds and blues in the background *(left)*.

Colorado River

The Colorado River built the canyon and snakes through it, powerfully leading the way. Our path took us miles alongside the river, and also to plateaus that gave us views from high above. I looked for areas where I could see multiple curves in the river, leading the eye down the canyon (*below*).

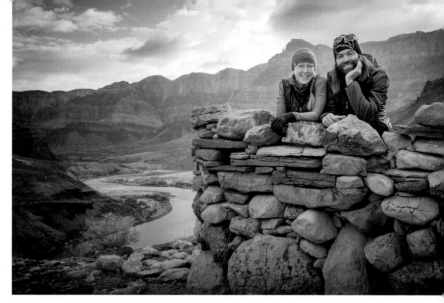

A Cold Night

This was one of the most memorable nights of the trip. I was excited to camp on a ridge with such an amazing view. We arrived in the late afternoon and pitched our tent. As soon as camp was set up, an intense wind began. It was so strong that we had to grab all our gear and retreat to a makeshift wall that had likely been built by travelers in a similar situation as us. After a hot dinner, we slept through a cold and windy night. The next morning, I documented the memory by setting up the tripod to get an image of the two of us (*above*).

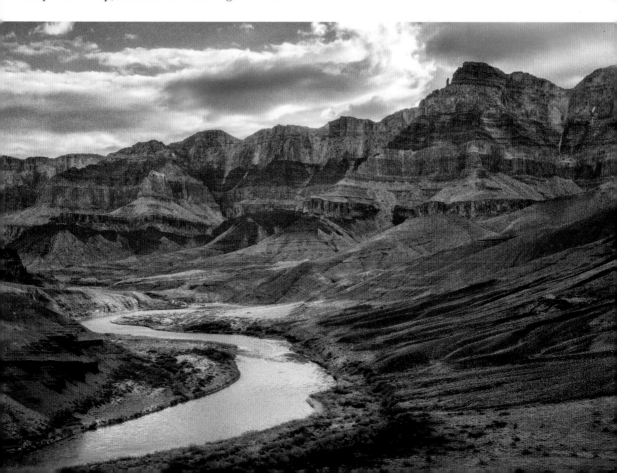

Bright Angel Creek

Along the massive Colorado River there are several smaller creeks. Situated on the Bright Angel Creek is a small camp for visitors. It was February and most of the leaves had fallen, but the trees along the creek felt like an oasis compared to the trail we had been on up to this point. This is the one image among the collection that feels as though it's from another place *(below)*.

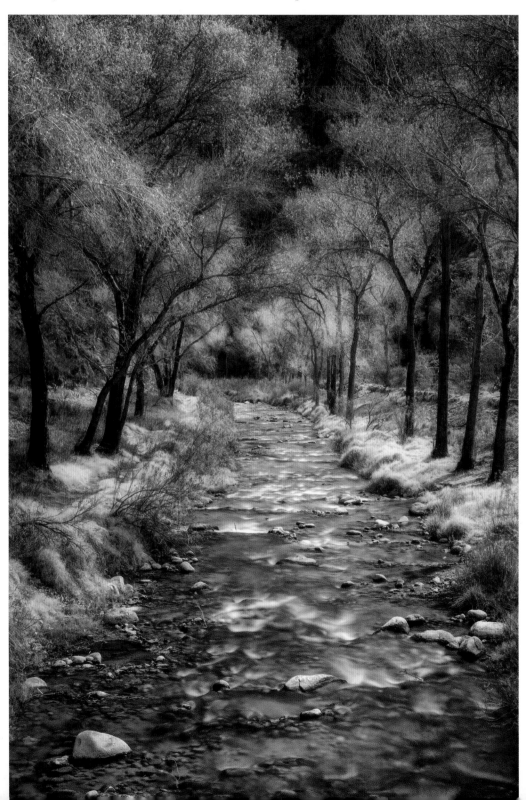

Final Sunset

From the bottom of the canyon, you don't see the traditional view of sunset you might experience on the rim. I was happy with the images I had captured so far, but on our last night we decided to add a few extra miles and hike out to a viewpoint for our last sunset *(below)*. This was the perfect ending to a remarkable experience. The sun lit up the texture of the walls with sharp contrast and the clouds were a perfect mixture of dark and brooding while still allowing just the right amount of sunlight

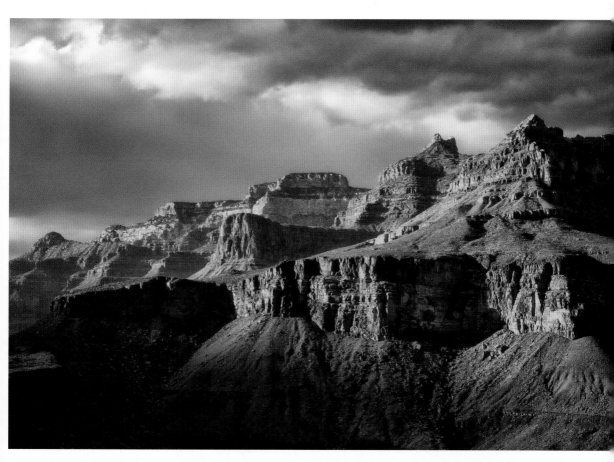

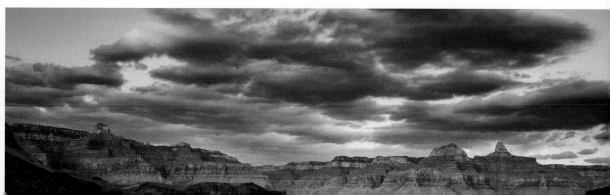

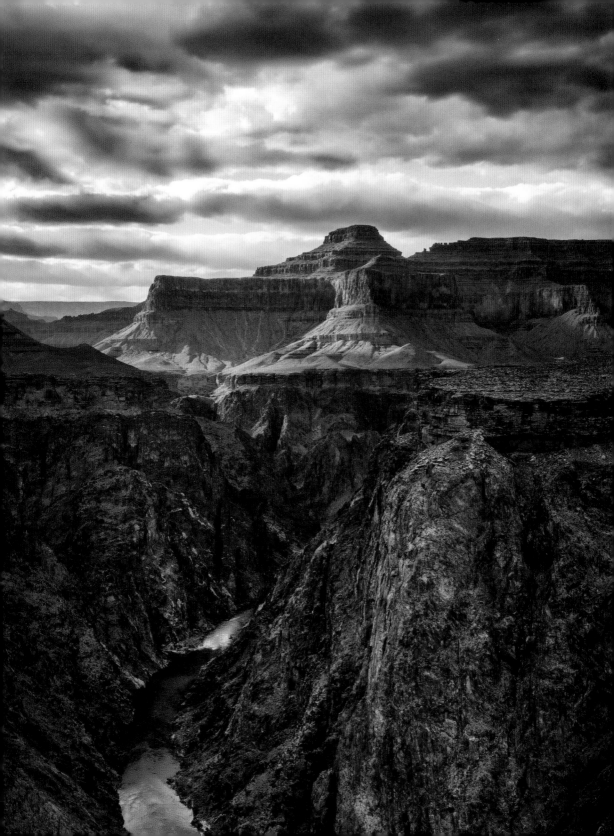

through. I spent a lot of time photographing many compositions from panoramic and landscape to vertical showing off the line of the river beneath *(facing page)*.

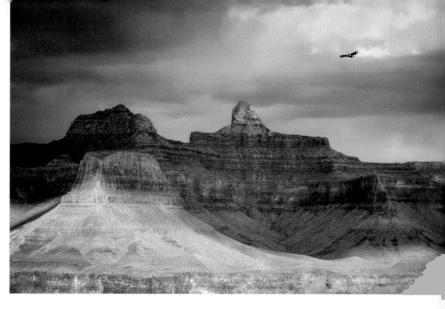

Condor

As a good omen to send us out of the canyon, we were graced by the presence of an endangered California Condor. Due to size and weight concerns, I didn't have a telephoto lens with me, but I was able to capture the bird as it soared high above the canyon *(top right)*.

Covered in Snow

The next day we hiked up and out of the canyon. It was cold and steep. We arrived at the rim covered in snow *(below)*. Freezing cold, I couldn't help but smile exuberantly at what I had just accomplished. I have never been great with words, which is perhaps why I am so drawn to photography. My images tell my story.

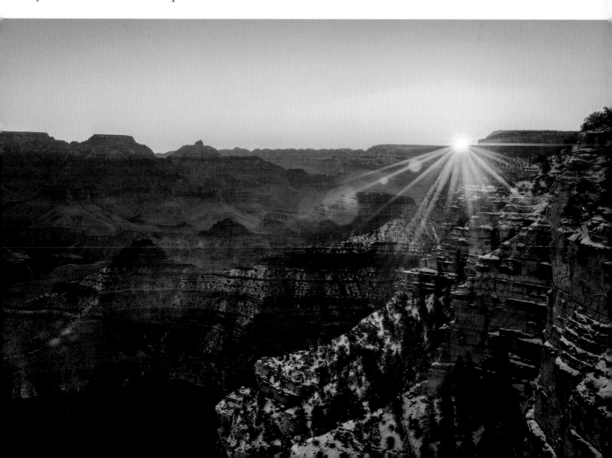

Grand Tetons

Back to the Beginning

Everyone has a place they are drawn to—a place that has captured their heart. For me, that place is the Grand Tetons. I've learned more about myself in these mountains than anywhere else on earth. When I brought Kendrick to these mountains for the first time, he fell in love with them as well. I knew he would. When we bring our teardrop here, we feel like we have the most amazing backyard in the world *(bottom)*.

A Promise Kept

When I first met Kendrick, before he even joined me in the teardrop, I told him about the Grand Tetons. I told him I daydreamed about climbing to the tip of the tallest peak, the Grand. For me, that was just a pipe dream; I could never do something on that scale. He promised me—a girl he barely knew—that he would take me to the top of this peak someday.

I didn't believe him. The universe must have had it out to prove me wrong, though; a year and a half later, I would be standing on the top of this mountain that I had been gazing at from below for so long *(below)*.

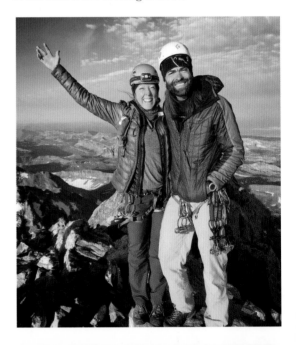

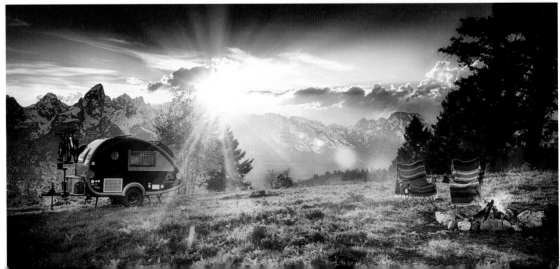

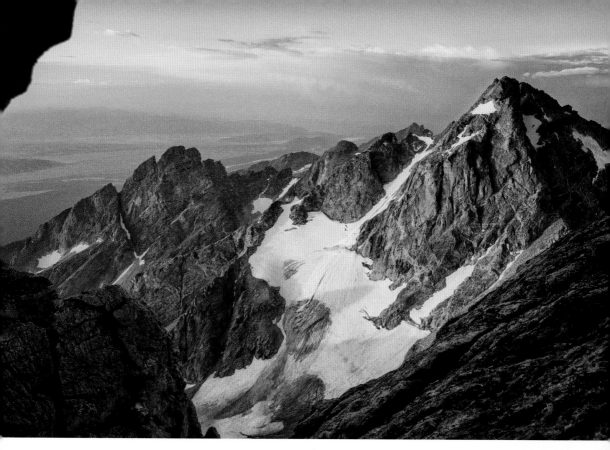

Of all of the thousands of photographs I have taken in the Tetons, this is my single favorite image *(above)*. It reminds me of our failed first attempt and the dejected feeling it left me with. I remember how Kendrick made me rest up and try again days later. And it reminds me not to limit myself based

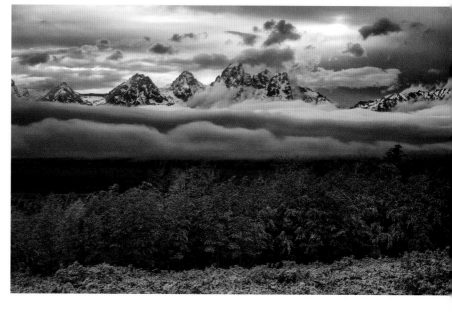

on what I believe I can or cannot do. I also love it because it is a perspective most people don't get to see. Rather than the typical straight-on view of the range, this view takes a lot of work to get to and so the image is unique to me. And

finally, I love it because it is the sunrise. We began hiking in the dark, and just as I was feeling I couldn't climb anymore, the sun rose at the perfect moment for me to take a break and create this image.

My Own Style

Every photographer has their own personal style. In the beginning, it tends to vary greatly as you experiment to find your inspiration. Over the years, it has been playing in this photographic playground that has helped me refine my style. I stood in the same location as historical greats such as Ansel Adams, but yet I made the image my own *(below)*.

Capturing the Magic

If I had to use one word to describe these mountains, it would be "magic." When I look at my images, they take me to a fairy-tale land that doesn't seem real. And just when I think I've seen it all, I discover something new. To capture the essence of this feeling, I focused on the way the sun brilliantly spotlights the flowers from behind, and the way the sun's rays burst through the sky at sunset *(right and facing page)*.

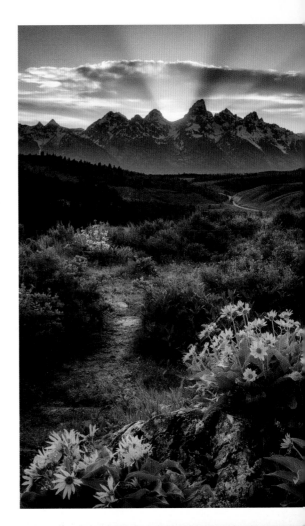

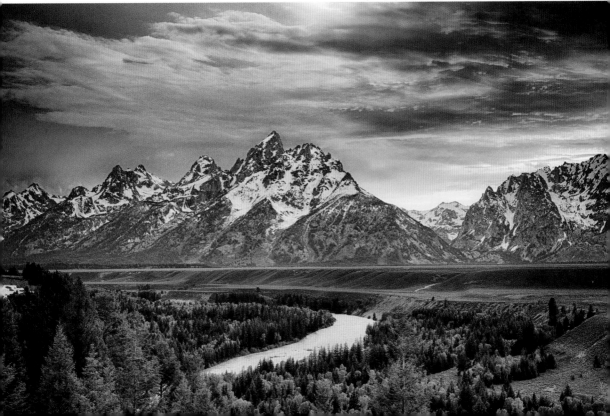

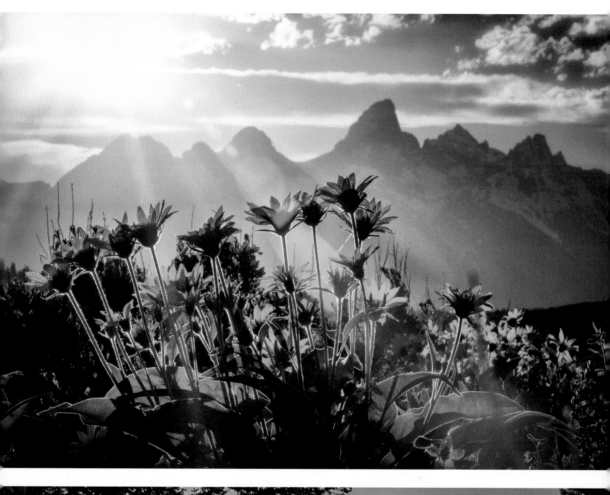
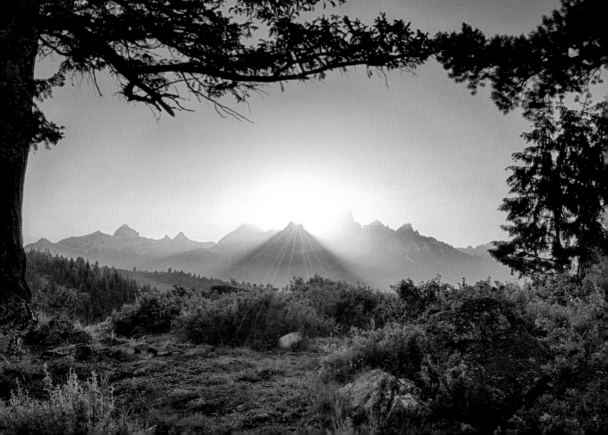

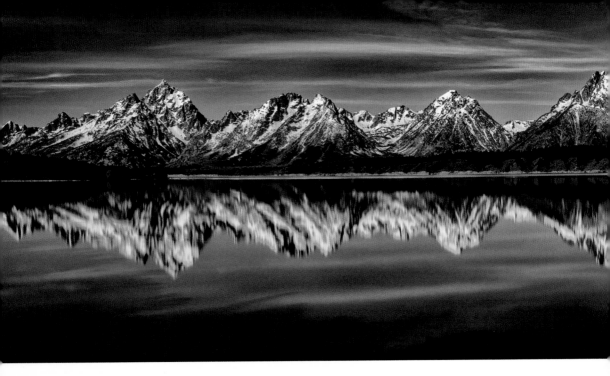

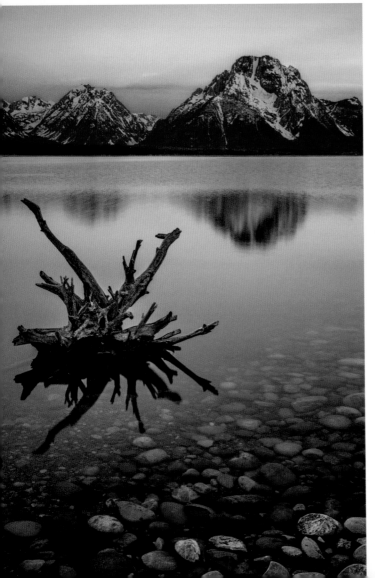

Unbroken View

I occasionally go through phases in photography, a common one being an obsession with creating multi-frame panoramic images. The long mountain range of the Tetons lends itself to this style. Here, I stitched together nine images to showcase the symmetry of the landscape with the reflection in the lake *(above)*. I chose to present this image in black & white in order to emphasize the patterns and contrast.

Colors

I also enjoy emphasizing the beautiful color palette that nature gives us. In this image *(left)*, there were numerous colors of rocks, all perfectly matching the subtlety of the moody sunrise. In other scenes, I will be drawn to a bold and vibrant color palette, such

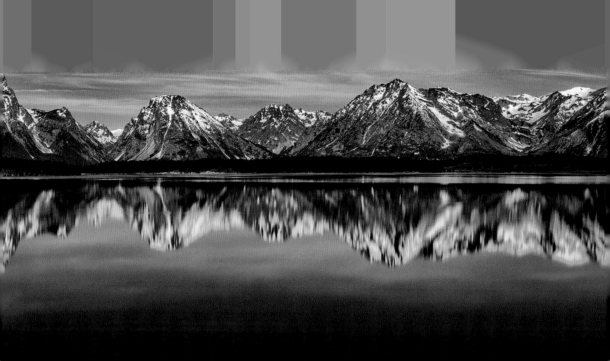

as these bright yellow flowers with vibrant green leaves in front of a deep blue sky *(right)*. I believe it is from these color combinations found in nature that we build our own graphic color sets.

I also enjoy emphasizing the beautiful color palette that nature gives us.

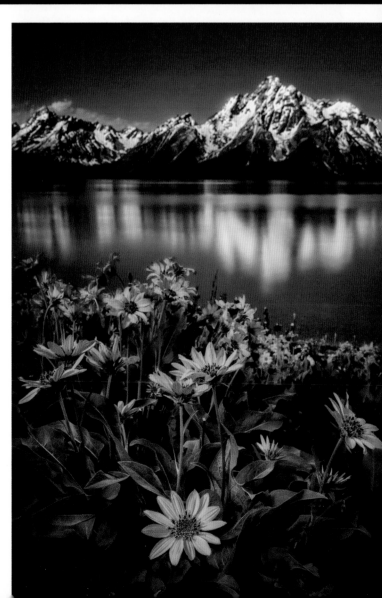

Waterfalls

If there was one thing I could change about Grand Teton National Park, I would wish upon it more waterfalls! But I do have to admit that the few waterfalls it has are quite spectacular. With the Grand Tetons as a backdrop behind heavily flowing rivers, it is impossible not to be inspired.

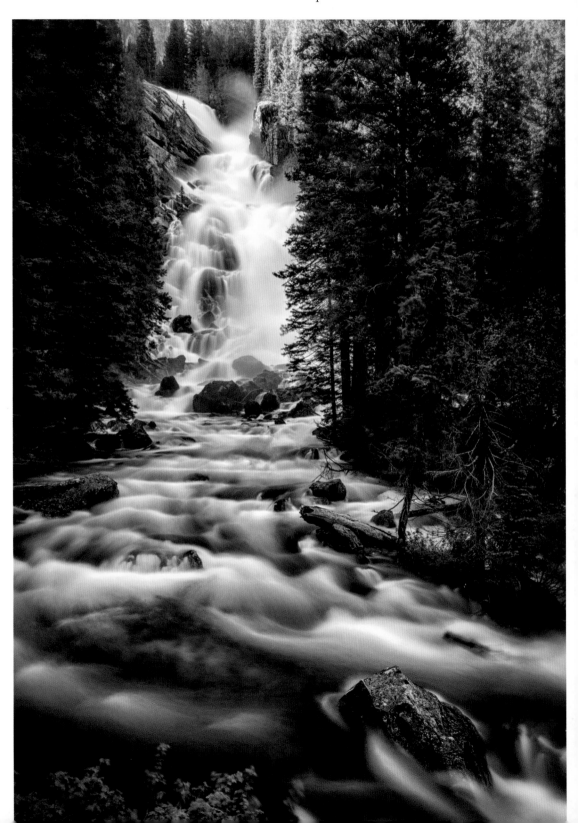

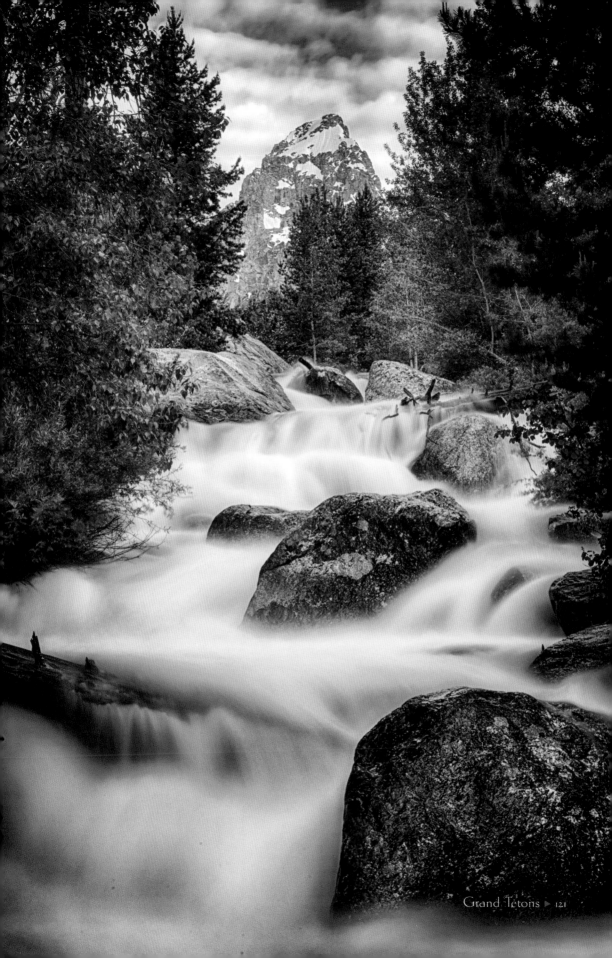

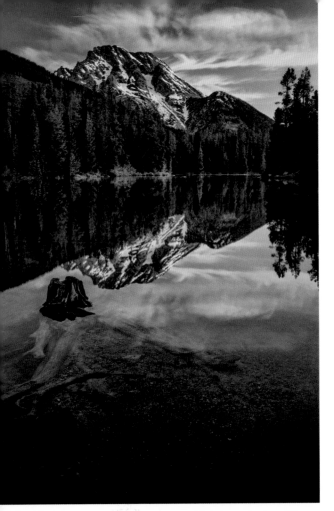

A Great Way to Learn

One would think I might tire of photographing the same location over and over. Rather, I find it a great way to learn. I've stood in the exact same spot year after year and I discover something new each time. With each day comes a new experience and with it, a new light. While I don't make it to every location each year, the one place I am sure to go is "the mountain that made me do it" *(bottom)*.

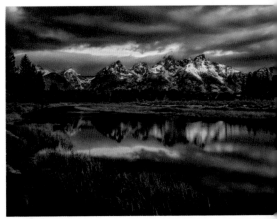

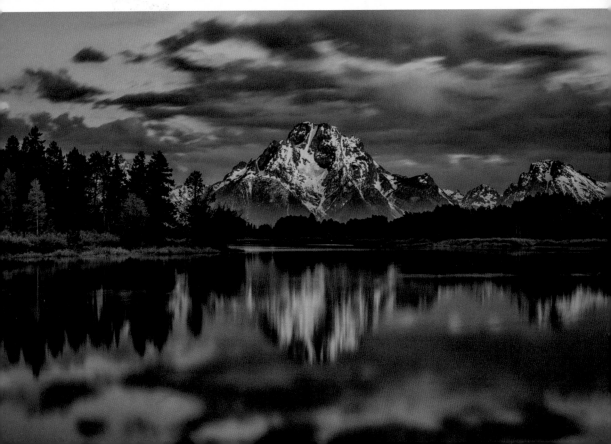

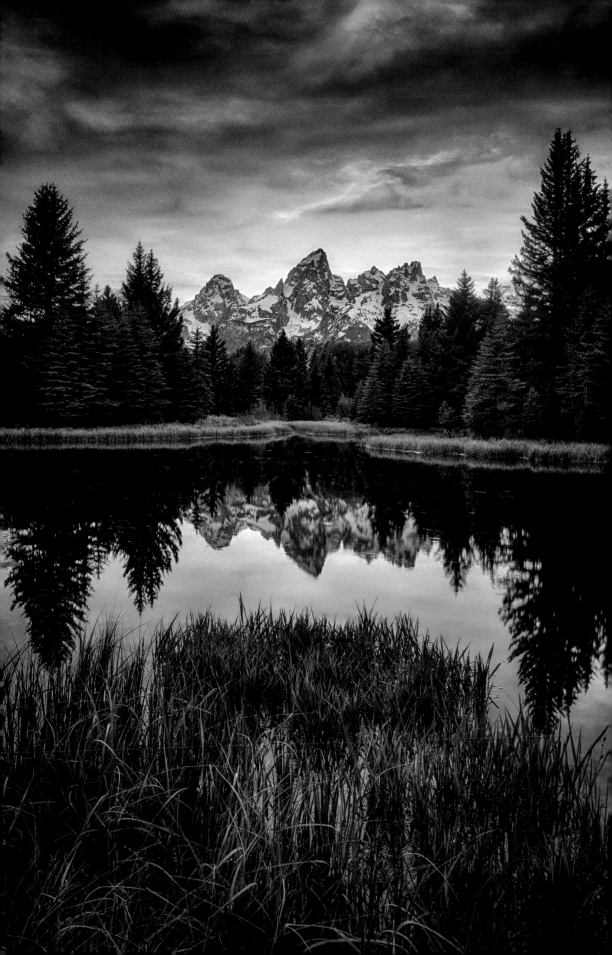

CONCLUSION

My Own Happy World

When I first told my friends and coworkers that I was moving into my teardrop trailer to live on the road as a traveling photographer, I was met with forced positive words followed by a question: "How long will you do it for?" I could tell no one thought I would last longer than a few months. And when a few months had passed people would ask me how my "trip" was going. I would tell them it wasn't a trip, but that my new way of life was making me happy.

This common line of questioning always highlighted that I didn't fit in with the mind-set of the majority of the population. When I go to events where I socialize with people living a traditional life, it seems as though we live in different worlds. I'm somehow just looking in from the outside. There is nothing wrong with a conventional life, and in some ways I wish it had worked out for me—it would be simpler. But I'm happy on the road, and I'd rather be happy not knowing what tomorrow holds than regretting not chasing my dreams.

When I look back at my life, I realize that the last three years on the road have given me more experiences than the first 33 years of my

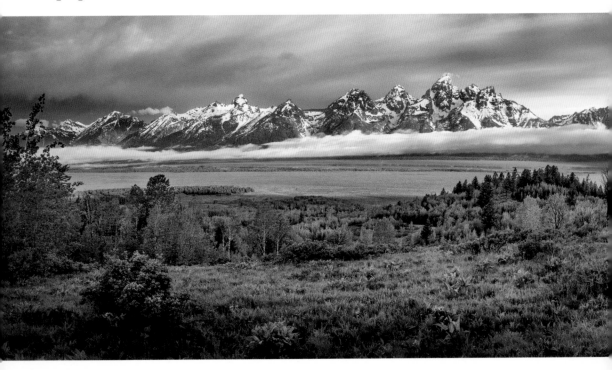

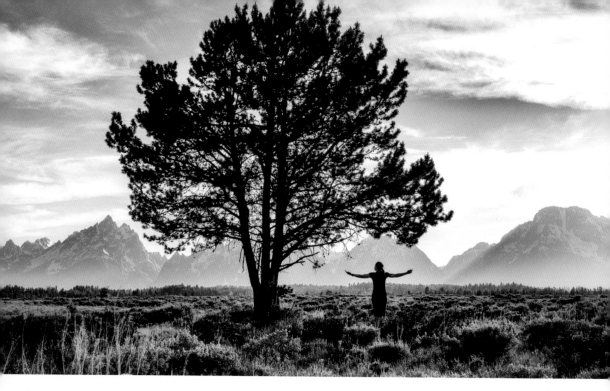

life combined. I've visited more places, met more people, and learned more about myself than I ever imagined. Despite my belief that it would never happen, I found someone to share these adventures with. I've become a better photographer, and a better person.

All of this is because I trusted myself. I threw caution to the wind and chased after my passion for photography and the mountains.

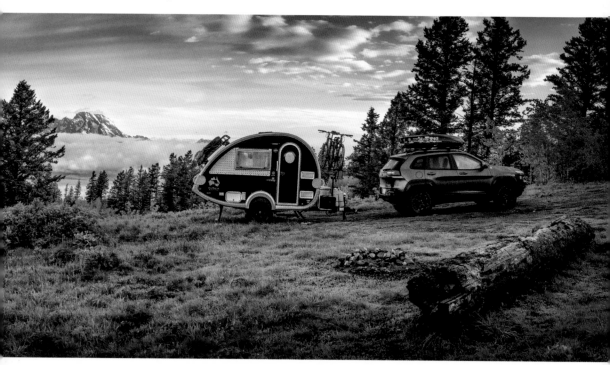

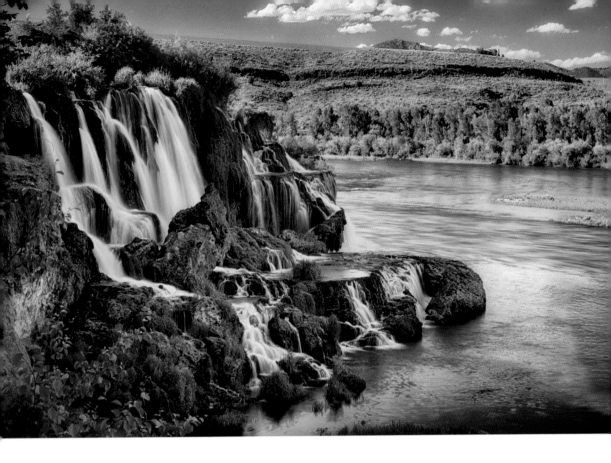

Index

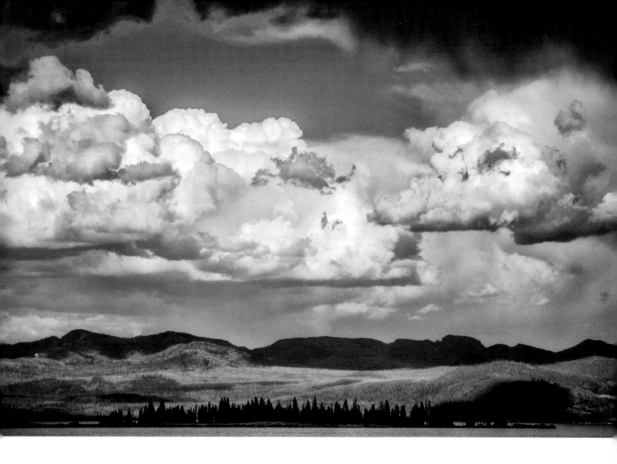

AmherstMedia.com

- New books every month
- Books on all photography subjects and specialties
- Learn from leading experts in every field
- Buy with Amazon (amazon.com), Barnes & Noble (barnesandnoble.com), and Indiebound (indiebound.com)
- Follow us on social media at: facebook.com/AmherstMediaInc, twitter.com/AmherstMedia, or www.instagram.com/amherstmediaphotobooks

Penguins in the Wild
A VISUAL ESSAY

Joe McDonald's incredible images and stories take you inside the lives of these beloved animals. $24.95 list, 7x10, 128p, 200 color images, index, order no. 2195.

National Parks

Take a visual tour through all 59 of America's National Parks, exploring the incredible histories, habitats, and creatures these lands preserve. $24.95 list, 7x10, 128p, 375 color images, index, order no. 2193.

Raptors in the Wild

Rob Palmer shares his breathtaking images of hawks, eagles, falcons, and more—along with information on species and behaviors. $24.95 list, 7x10, 128p, 200 color images, index, order no. 2191.

Trees in Black & White

Follow acclaimed landscape photographer Tony Howell around the world in search of his favorite photo subject: beautiful trees of all shapes and sizes. $24.95 list, 7x10, 128p, 180 images, index, order no. 2181.

Bushwhacking: Your Way to Great Landscape Photography

Spencer Morrissey presents his favorite images and the back-country techniques used to get them. $37.95 list, 7x10, 128p, 180 color images, index, order no. 2111.

Rocky Mountain High Peaks

Explore the incredible beauty of America's great range with Brian Tedesco and a team of top nature photographers. $24.95 list, 7x10, 128p, 180 color images, index, order no. 2154.

Owls in the Wild
A VISUAL ESSAY

Rob Palmer shares some of his favorite owl images, complete with interesting stories about these birds. $24.95 list, 7x10, 128p, 180 color images, index, order no. 2178.

Polar Bears in the Wild
A VISUAL ESSAY OF AN ENDANGERED SPECIES

Joe and Mary Ann McDonald's polar bear images and Joe's stories of the bears' survival will educate and inspire. $24.95 list, 7x10, 128p, 180 color images, index, order no. 2179.

Wild Animal Portraits

Acclaimed wildlife photographer Thorsten Milse takes you on a world tour, sharing his favorite shots and the stories behind them. $24.95 list, 7x10, 128p, 200 color images, index, order no. 2190.

The Frog Whisperer
PORTRAITS AND STORIES

Tom and Lisa Cuchara's book features fun and captivating frog portraits that will delight amphibian lovers. $24.95 list, 7x10, 128p, 350 color images, index, order no. 2185.